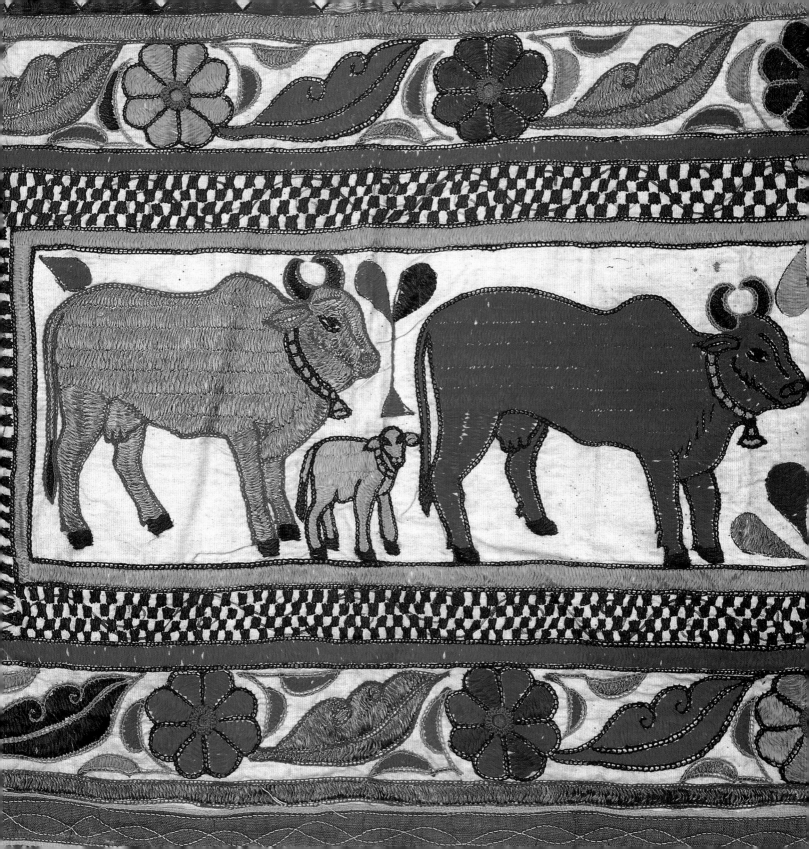

SHEILA PAINE

embroide

and

stan

THE BRITISH MUSEUM PRESS

© 2001 The Trustees of The British Museum

Sheila Paine has asserted the right to be identified as the author of this work.

First published in 2001 by The British Museum Press
A division of The British Museum Company Ltd
46 Bloomsbury Street, London WC1B 3QQ

A catalogue record for this book is available from the British Library

ISBN 0-7141-2744-2

Commissioning Editor: Suzannah Gough
Designer: Paul Welti
Cartographer: Olive Pearson
Origination in Singapore by Imago
Printing and binding in Singapore by Imago

COVER: Detail of a woman's shift; Swat Kohistan, northern Pakistan. (See pages 80-1)
INSIDE COVER: Detail from a bedding cover; Patel farmers, north-west Pakistan. (See pages 38-9)
PREVIOUS PAGES: Detail of a door hanging; Saurashtra, north-west India. (See pages 22-3)
THESE PAGES: Detail of a woman's dress; Sindh, southern Pakistan. (See pages 76-7)

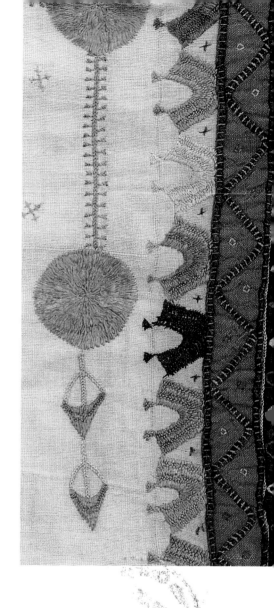

contents

Opposite are details from a selection of textiles
TOP: Silk fabric embroidered with fine chain-stitch in typical Mochi style; Kutch, north-west India. (See pages 28-9)
LEFT: Child's dress from the Lohana Community in Sindh, southern Pakistan. (See pages 68-9)
RIGHT: Boy's woollen coat embroidered with chain-stitch; Chitral, northern Pakistan. (See pages 60-1)
BELOW: Circles of radiating stitch are centred by a spot of colour; Saurashtra, north-west India. (See pages 38-9)

introduction

Colour is the vitality of the Indian landscape — the flash of an emerald sari in a barren field, the glow of a marigold necklace on a dusty wayside shrine, the softness of pink, coral and ochre turbans swirled together as Sikh men converse in a sandy lane, the zing of a puce and scarlet dress in the bleached Makrani desert. It is the brilliance of colour in an arid setting that is the very essence of India.

The everyday dress of the people of India sets a kaleidoscope to our eyes: a cluster of village women can dazzle with the blue of stained glass, the red of a gashed wound, the

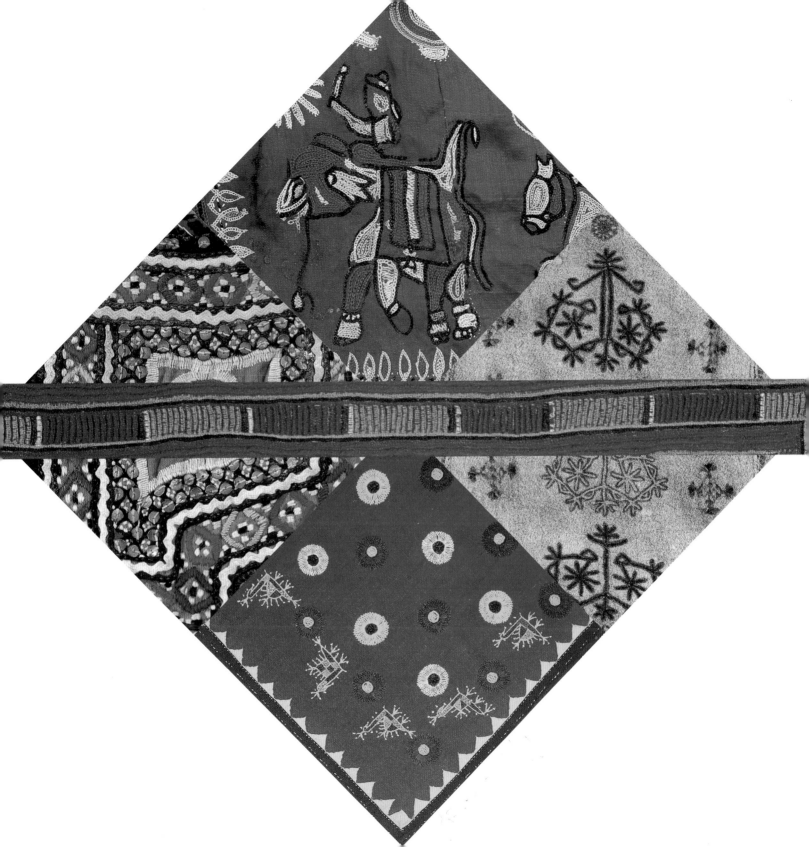

The embroidery of each village and each tribe is distinct, and the political boundary between India and Pakistan is thus largely irrelevant. For example, the embroidery of the Rabari, who wandered across the Tharparkar desert and now live on both sides of the border in Kutch and Sindh, is peculiarly Rabari, not Indian or Pakistani.

It is this region straddling the political frontier that is the hub of domestic embroidery in the Indian subcontinent. It comprises on the Indian side western Rajasthan, Gujarat, Saurashtra and Kutch, and on the Pakistani side Sindh. Punjab, to the north of this area and also now divided by the border, is another source of embroidery, as, in Pakistan, are the regions of Baluchistan and Hazara, and the high valleys of the North-West Frontier Province: Chitral, Swat and Indus. These are all relatively isolated areas, some—like eastern Sindh, southern Baluchistan and the valleys of Indus Kohistan — being accessible only with a police permit, and often an armed guard. In India there is also the *kantha* quilt tradition of Bihar and Bengal in the east, and across the Deccan plateau the work of the Banjara.

Most of the embroidered textiles for which India was historically famous — such as the shawls of Kashmir, the floral work of Gujarat and the *chikan* whitework of Lucknow and Bengal — were professionally made for the open market and are not the subject of this book. It is, instead, domestic embroidery made by a woman for her own dowry or for her family that is featured here.

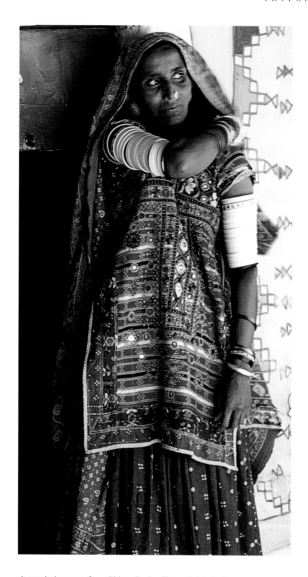

A married woman from Bhiren Daria village, Kutch, India.

greens of lime juice, of mint, of a splatter of parakeet feathers. To add embroidery to this intensity of colour would seem an unnecessary embellishment, but it has a more significant purpose — it both identifies and protects.

THE EMBROIDERERS

Considering the hub area first, this is an arid region where herders, nomads and subsistence farmers live. It is their womenfolk, most of whom live in relative, or even dire, poverty, who are responsible for some of the richest embroidery in the world. They are both Hindu and Muslim, but over the centuries they have intermingled and adopted many of each other's customs.

One significant difference everywhere, relating to religion, is that the Hindu women will often have greater freedom of movement than many Muslim women, who never leave their small village and its immediate environs. A woman of the Palas valley in Indus Kohistan, for example, will spend all day in a windowless, smoke-filled hut, emerging only to fetch water from a nearby stream and wood from the forest. Such a woman will continue to work in a totally traditional way, her only contact with the outside world being the materials her husband brings her. Nomadic women, on the other hand, will travel great distances with their herds and belongings, and will be open to influences from the villages they pass through.

All women have a heavy workload. They normally have to walk many miles to haul water and gather firewood, and, in addition, there is corn to grind, bread to bake, meals to cook, children to bear and raise. Embroidery would seem to be a superfluous activity, but in fact is a social necessity, not least because a woman must present a number of embroideries as her dowry. She begins work on them around the age of six — traditionally, in many countries, when her first tooth falls out — and continues to embroider for most of her life. She will be taught by her mother and other women of the family, and will copy the old textiles around her.

How long an embroidery takes her will depend on how much time she has available, which is obviously far less for a married woman with children than for a younger girl. A doctor's wife in Makran, southern Baluchistan, for example, with servants to care for her children, will still take an entire year to embroider a traditional dress for herself. The dowry of a Kanbi woman of Kutch would usually take five or six years to embroider, while the bodice of a Jath woman's dress can take anything from two months to three years. Most women embroider in the winter months when there is less outdoor work to do.

THE EMBROIDERIES

There are often many tribes and castes living together in the same area, and the women's clothing serves to identify them, defining not only the group to which they belong, but also their social status. A married woman, for example, will generally wear costume that is more subdued in both colour and pattern than that of a younger girl.

The costume the women make for themselves depends on the traditional dress of their group. For the Muslim women of

Pakistan it will usually be a shift of between knee and mid-calf length, cut straight or flared. (Such a dress has a different name within each group.) It will be embroidered over the front bodice, the shoulders and the sleeves, and will be worn with trousers (*shalwar*) embroidered at the cuff.

The costume of north-west India — Kutch, Rajasthan and Gujarat, and also Sindh — is an open-backed blouse (*chola*), solidly embroidered, worn with a full, gathered skirt (*gaghra*), generally embroidered at the hem and often with scattered motifs over the ground.

Jath women of Kutch wear an ankle-length, full-skirted dress (*chori*), richly embroidered over the bodice front. The Banjara of the southern Deccan wear skirts with very deep embroidered waistbands.

An essential element in all these different costumes is the shawl, usually made of brightly printed, commercially produced fabric. The sari does not form part of tribal dress, and those that are embroidered are professionally worked in, for example, goldwork or *chikan*.

Women also embroider clothing for their children in the same styles as adult wear, concentrating particularly on jackets, dresses and caps, the decoration of which usually plays a talismanic role. Sling cradles, for use in the home and to carry babies when families are on the move, are also embroidered.

For their menfolk, some tribal women embroider marriage shawls and scarves, and others make elaborate guncovers and tobacco pouches, while for their homes they pay great

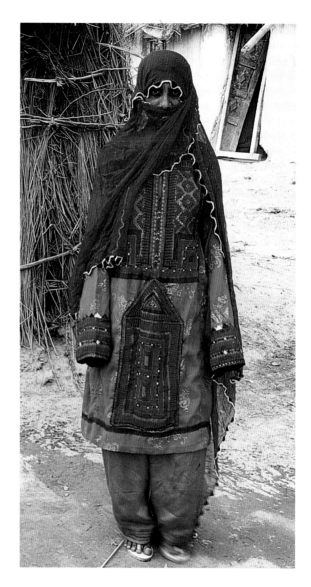

A woman in the local dress, which is worn every day. Sunsar village, Makran, Pakistan.

attention to the decoration of food covers, bags for many purposes, quilts and cushions. In most places all these richly embroidered textiles are in everyday use. Door hangings

10

are especially used for festive occasions, and at such events — marriages, religious festivals, fairs — embroidered animal regalia also displays the wealth of the family.

THE MATERIALS

Cotton is the predominant fabric used by the women to make both clothing and domestic articles. Most of it is produced in India, either hand-woven in local workshops or machine made in large cotton mills.

Silk is used by some communities, both for festive dress and for everyday wear. This is true, for example, of the merchant classes of Kutch. In Baluchistan, however, Chinese silk is rapidly being replaced by the more readily available Japanese polyester.

Wool is the obvious choice for some of the shepherding groups, such as the Rabari. This is often locally woven, or made by the women themselves, as in Chitral, where looms can be seen set up against the small stone houses.

Fabrics can be decorated by the tie-and-dye technique, whereby cloth is pinched into small balls and then tied tightly with thread. Women's shawls, for example, are often tie-dyed by women and girls at home. A red background with white and yellow dots is the most common colour combination.

Block-printed cotton of a rather coarse weave is over-embroidered, for example in the marriage shawls of men of the Meghwal caste. Block printing is done with a resist substance by both Muslims and Hindus of the Khatri caste, and block printers can still be found in many villages. The background fabric for this work is normally red. Red is the most significant and powerful colour in the folk embroidery of most of the world. Its association with life and death, with fire and the power of the sun, with blood and vitality, imbue it with a potency that is considered auspicious for marriage and for the young: a girl's dress will be red, a widow's white.

The exhilarating red of Indian textiles derives from the dyers' hereditary skill in combining a mordant with alizarin, a pigment present in the root of madder, and in other plants, and now produced chemically. Chemical dyes have long since largely replaced the natural dyes for which India was once famous, but the innate skills of the dyers have ensured the survival of a unique vibrancy of colour.

Certain villages are renowned for their expertise in dyeing and the use of mordants, skills that have been handed down within families through generations. Whereas wool and silk are considered pure fabrics and are dyed by upper-caste Hindus, cotton is seen as tainted and if the dyers are Hindu they are of a low caste. The seemingly magical ability to change a substance, as with blacksmiths, placed such artisans at the fringes of a superstitious society.

In north-west India cotton dyers are almost entirely Muslim, usually Khatri. In backyards cloth is boiled in alizarin, or steeped in indigo vats. Turmeric, though fugitive, is another colouring used. There is a limited palette of colour among many tribal groups, the shocking

pink of Swat being one example, the dominant yellow and white of the Rajput and Rabari another, and the strict discipline of the six colours of Makrani embroidery yet another.

The threads used for embroidery are floss or twist silk, and cotton, though acrylics are gradually creeping in, and having a detrimental effect on workmanship. Threads are manufactured in India or Pakistan and are sold in local markets or by pedlars. A market stallholder or pedlar will only trade in those threads and colours he knows the women traditionally work with, so there is little opportunity to introduce new colours.

Gold and silver, either jap threads or lurex, are used by some groups to add sparkle, while almost all use mirror glass, known as *shisha* or *abla*. Specially produced globes of such glass are cut into small pieces to be sold. While on many garments these inset circles of mirror do no more than flash pleasingly in the bright sunlight, one isolated piece sewn on to the centre back of a small child's jacket has an obvious talismanic potency.

A talismanic role is also played by cowrie shells, red seeds, old zips, white buttons, silver trinkets, sequins, bits of watch chain and dangling triangular amulets, as well as by tassels and pompoms, especially in the embroideries of Indus Kohistan. To a people with almost no understanding of the spread of disease, such trinkets are believed to afford protection from the evil eye and from malevolent spirits that can cause illness and death.

A similar purpose is served by the decorative stitching and applied triangles around the bodice slits to facilitate breast-feeding that are found on Baluchi dresses. Such decoration is believed to protect the mother's breasts — the source of life for the baby. For the same reason, the breast area is the one most ornately embroidered in the case of nearly all folk costume.

Another decorative device of the costume of Pakistan, through to Afghanistan and Central Asia, is the insertion of vivid contrasting underarm gussets that form part of the original garment. These are often outlined with exceptionally fine stitching.

STITCHES

All embroidery is based on either counting threads or following freely drawn lines. In the indian subcontinent both techniques are used, but very rarely in the same piece of work. The counted-thread work is known as *soof* and results in small geometric patterns. Drawn patterns are usually the work of the embroiderer herself, though sometimes a particularly skilled woman will draw for others in her village. Patterns are also printed with blocks, as in Sindh and Saurashtra.

Many of the stitches used are found worldwide, particularly chain, open chain, satin, surface darning, darning, stem, couching, herringbone and cretan. Some, although found in other parts of the world, are here taken to their highest degree of perfection — as, for example, is interlacing in

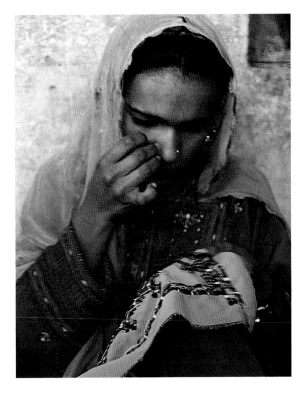

This Pakistani girl from Sharpak village in Makran rests the needle in her nose whilst taking a pause from her embroidery.

Baluchistan. Others are unique to the Indian subcontinent, such as the stitch used to attach mirror glass, where a grid of holding stitches are drawn towards the centre by interlacing or buttonholing. A variation, known as radiating stitch, forms a circle, the interlacing stitches being taken through the cloth instead of around the mirror glass. This stitch in floss silk is a feature of the work of Sindh.

Surface darning, worked from the back of the fabric in floss silk, is the stitch used in the *phulkaris* of Punjab and also the work of Swat Hazara, Swat Kohistan and Indus Kohistan.

Chain stitch is characteristic of the Mochi of Gujarat, who embroidered not only for their own purposes, but also to commission for the courts of local rulers and for other clients, and even for export to Europe. Originally leatherworkers, their embroidery — done on a tambour with either a needle or a type of hook called an *ari* — is extremely fine.

Quilting and appliqué, frequently combined with other stitchery, are both important techniques in many parts of India and Pakistan.

PATTERNS

Almost all patterns are symbolic, the motifs being thought to bring fertility or prosperity, or protection from evil spirits. Many relate to Hindu beliefs. Ganesh, the elephant god who ensures happiness, is the central motif of many *torans* hung on festive occasions, especially weddings, and is popular among the Kanbi caste. Krishna and the *gopis* (cowherding girls) and sacred cows are worked on such articles as temple hangings, canopies and small cloths. Lakshmi, goddess of wealth, is depicted as herself and also in the form of a lotus. Motifs taken from domestic life can also have religious or mystical associations. That of two women churning curd, for example, relates also to the gods churning the heavenly ocean. Elephants and tigers, camels and horses, peacocks and parrots, even scorpions, have overtones of symbolism. Flowers, leaves and mango trees are depicted realistically, or

often, in the case of flowers, as rosettes that merge into solar symbols.

Such figurative patterns are not to be found in Muslim work, which relies on geometric and linear patterns. There is a striking contrast between the Hindu *phulkaris* of eastern Punjab, which show lively scenes from everyday life, and those of the Muslims of western Punjab and the Sikhs of Hazara. The beauty of the elegant, disciplined embroideries of the Muslims and Sikhs derives solely from the play of light on floss silk and changes in stitch direction, combined with perfection of technique. The Muslim embroideries of Pakistan in general all share this austerity of pattern, technical skill and juxtaposition of colour as their source of beauty.

THE TRIBES

Through the ethnographically complex region of north-west India, across the desolate salt marshes of the Great Rann of Kutch and the Tharparkar desert into Pakistan, in spite of enormous diversity and some mutual influence, certain distinguishing characteristics of colour, stitch, pattern and material can be determined in the work of the major tribes.

Among the Hindu castes are:
RABARI: these nomadic shepherds and herders make shawls of black wool tie-dyed in yellow, orange or red dots, which they embroider in floral motifs in yellow open chain stitch, and decorate profusely with *shisha*. Cowries and tassels of cloth may also be added. The men wear white smocks embroidered over the bodice and sleeves in vivid colours and linear patterns.
RAJPUT: characteristic of this ruling caste, now farmers and herders, is coarse yellow and white interlacing in square and diamond patterns, as well as open chain stitch and mirrorwork, especially in squares. Touches of green, orange and pink, often in floss silk, enliven their work, which is usually on indigo or cinnamon-colour cotton.
KANBI: this farming caste of Kutch work motifs of flowers, parrots and peacocks in pink, yellow, white and green chain stitch on red cotton. The Kanbi make many small items — children's clothes, fans, door hangings — including some with Ganesh, the elephant god, as a motif. They also make wrap-around overskirts, and shawls (*sadlo*) presented to a woman after one year of marriage. These have a very ornate border with motifs depicting women dancing, or churning butter, and also squares and swastikas of white and yellow interlacing. The Kanbis of Saurashtra embroider in herringbone.
MEGHWAL: this caste of leatherworkers, living mainly in the Tharparkar desert, though found from Rajasthan to Sindh, are renowned for their men's marriage shawls (*malir*) of resist-printed red cotton, embroidered with stylized peacocks and flowers in open chain stitch. These patterns symbolize fertility and prosperity for the bridal couple. The flowers

are in cream silk or cotton, the rest of the embroidery in deep shades of oranges, reds and mauves, outlined in black. Meghwal embroidery also includes mirrorwork.

LOHANA: a Hindu enclave at Thano Bula Khan in the Sindh desert, these people, who also live in Kutch and Tharparkar, are best known for their wedding shifts (*guj*). These are straight, knee-length garments, the front and back both divided into two blocks of different-coloured cotton — red, orange and black. The embroidery is very heavy, mainly in turquoise chain stitch, with some gold thread, mirror glass and sequins. Some work is also in orange and white. The motifs are stylized flower heads and squares.

SUTHAR: the embroidery of this carpenter caste is of counted-thread surface darning. Small geometric patterns, very Muslim in character, and stylized animals are worked in red, yellow, green and blue silk thread.

SODA RAJPUT: this farming caste embroider on a red cotton background fabric, dividing it into bars by rows of satin stitch, and there are touches of white chain in tiny floral motifs, and small areas of interlacing in yellow and green. Items made are shifts, purses and clothing for children.

Among the Muslim groups are:

MEMON: the short, flared marriage dress (*aba*) of this merchant community of Kutch is made of silk fabric, embroidered over the sleeves, bodice and stomach in a pattern that culminates in a large five-petalled motif over the genital area. The stitching — interlacing, chain and buttonhole, in a variety of colours — is extremely fine. The motifs are floral and very tiny pieces of *shisha* are used. The hem can also be embroidered, and occasionally small floral motifs are worked over the entire garment.

JATH: these semi-nomadic camel-breeders and herders of Kutch are among the oldest inhabitants of the region. The women embroider the bodices of their *chori*, which are usually black, in a grid pattern with large round or pear-shaped *shisha* set in columns. They have a strong sense of colour, working in

A woman embroidering in Ludia, Kutch, India.

orange, green, blue, black and white threads. The Gracia group of farmers use a distinctive tiny white cross stitch.

REGIONS

The Punjab, lying in both India and Pakistan, is famous for the shawl known as the *phulkari*, embroidered by Hindu, Muslim and Sikh alike. This is made of a local cotton dyed a cinnamon colour (*khaddar*). The stitch used is surface darning, worked from the reverse, and the threads are of yellow and white floss silk, with touches of purple, green or pink. Shawls entirely covered in stitching are known as *bagh* and were traditionally presented as gifts, especially on the occasion of a marriage. Patterns used by the Muslims and Sikhs are entirely geometrical, while those of the Hindus include some figures and animals.

The dresses of the Baluchistan province of Pakistan are calf length and wide cut, with tapering long sleeves and a bright, contrasting underarm gusset. They are worn with the loose trousers known as *shalwar*. Today the fabric is usually Japanese polyester, though it used to be vivid silk of Chinese origin. Some groups use white cotton. A distinctive feature of Baluchi dresses is the *pudo*, a long pocket rising from hem to stomach, where it ends in a triangular shape. This is densely embroidered, as is the bodice front. Vertical lines, often divided by rows of chain stitch and of black thread held by small white stitches, are a feature of Baluchi embroidery. This patterning changes over the breast area into a wider

design field, often featuring a motif of a staggered cross at the shoulder, with an arrow shape below. Fine interlacing stitch, usually in yellow (except in the case of Makran, where it is always worked in red) is another feature. Makrani embroidery only ever uses red and

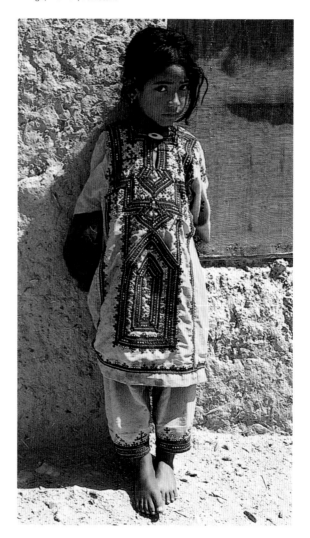

A little girl wearing the braided version of the local costume. Issai village, Makran, Pakistan.

burgundy as the principal colours, with black and white, royal blue and dark green in balanced contrast. The Brahui group have no *pudo* and a more open style of embroidery over the bodice, but still retaining the square and arrow pattern. The stitching is often in a mauve shade. The Bugti, who also have no *pudo*, enliven the front neck opening with circles of orange, black, green and purple.

In the North-West Frontier Province of Pakistan, three river valleys flow from north to south through the Hindu Kush and the Karakoram. In the westernmost, Chitral, the men's dense natural woollen coats are embroidered in chain stitch with patterns of rams' horns, a motif that comes from central Asia. The small group of pagan Kalash people living in this region cover their woollen hoods with cowrie shells and edge their black cotton dresses with linear machine embroidery.

The hallmark of the central valley of Swat is a love of shocking pink. Short shifts of black cotton are embroidered with geometric patterns in darning stitch, with a distinctive voiding. In the region of Hazara, slightly to the south, white cotton is preferred and a greater range of shades is used in the designs — from mauve to pink to red. There is an affinity in Hazara work with the *phulkaris* of Punjab.

In the region of Hunza to the north of the easternmost of the three valleys, the Indus, the women still embroider and wear pillbox caps worked in fine cross stitch. In the isolated tributary valleys of the Indus, a unique dress that used to be worn is the *jumlo*. This extraordinary garment is of black cotton, with deep wide sleeves and a short flared skirt of literally hundreds of godets. The bodice and sleeves are embroidered in red floss silk in surface darning, with sections of cross stitch on the cuffs and often fine cross-stitch and Florentine work at the neck opening. The patterns are solar and geometrical and are outlined in small white beads. The dresses are hung with amulets and adorned with coins, buttons, old zips and other talismanic devices. Marriage shawls in the same style are still made, but the *jumlo* itself has been replaced by a short shift, embroidered in the same style but showing slightly more Swati influence in the use of a vivid pink colour and voiding in the stitching. An entirely different patterning is that of meandering plant-like motifs worked in chain stitch, and both styles may be used indiscriminately by the same woman.

Leaving Pakistan to consider India, the work of the Banjara is pre-eminent. The Banjara were the great traders of India, criss-crossing the subcontinent with their bullock caravans bearing salt, grain, areca nuts and other precious commodities. When the British built the railways in the nineteenth century, they began to settle in the Deccan plateau, and now work in a wide variety of occupations. There are differences in the embroidery of each of the areas where they settled, but in general there are two main styles. The Banjara of the south work dense stitchery in geometric patterning, in predominantly

chain, feather and satin stitch in subtle shades of red, yellow, white, blue, green or light brown. Those of central India work sparse embroidery on patches of indigo-dyed cotton and cinnamon *khaddar*. Here the stitching consists of small white open dots, and white cotton cloth is appliquéd in a zigzag pattern. Many Banjara embroideries are edged with cowrie shells. The southern Banjara make wide waistbands for skirts, while all make bags and small cloths for various purposes, suited to their peripatetic lifestyle. For marriages they make bags especially for the bridegroom, as well as animal regalia such as bullock horn covers.

A folk tradition of north-eastern India is *kantha* work. Although the major region for this embroidery, Bangladesh, now lies outside India, the division is only political — *kantha* quilts and coverings were made throughout the whole area of Bengal and Bihar. Originally made of layers of worn-out old white saris, *dhotis* and *lungis*, the *kanthas* were stitched with threads of red, black, blue and white said to have been pulled from sari borders.

The range of motifs is wider than in other Indian embroidery, embracing as it does the usual Hindu symbolism — the goddess Lakshmi accompanied by an elephant, the chariot of Vishnu or Jagannath, the lotus, the horse and elephant as symbols of wealth — while also encompassing a plethora of everyday articles. These include cosmetic items such as mirrors, combs and kohl-bags, as well as domestic equipment and farming tools. The lotus normally forms the central pattern, with an oblique tree of life in each corner and the rest of the field scattered with these small motifs from daily life. Boats and fish, wheels and swastikas add further symbolism.

The stitch used is a running stitch worked in ripples, or encircling motifs so that they are slightly raised from the background fabric. Pattern darning fills the motifs.

Kanthas used to be stitched by women for their families during the long rainy days of the monsoon. Now they are a marketed commodity, and one of the success stories of the survival of folk embroidery in a climate of change that has led to the decline, or even disappearance, of much of the rich heritage of domestic needlework.

TRADITION AND CHANGE

The most important factor for change in the Indian subcontinent is the education of girls. The preparation of her dowry used to involve a girl in spending most of her youth stitching. Without all the embroidered garments, domestic textiles, animal and marriage accoutrements and gifts for the bridegroom that had ritual significance in her social environment, a girl could not hope to find a husband. Now, with a degree in engineering, for example, she can manage without either the embroideries or the husband. And even if she merely finishes primary school, those early years will have been spent with pen and paper instead of thread and cotton.

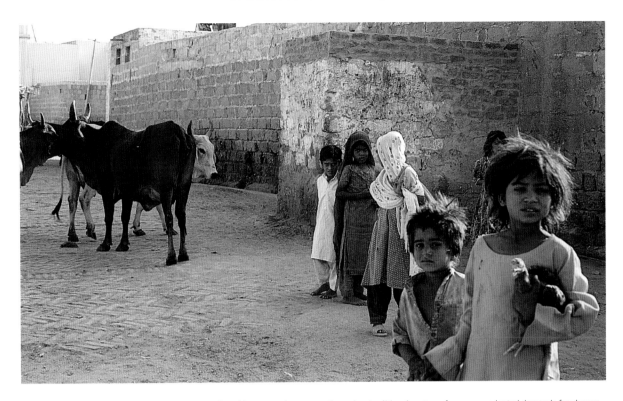

Children in the small town of Thano Bula Khan, Sindh, Pakistan, growing up at a time when traditional customs face unprecedented demands for change.

In India, at the same time the caste system is gradually breaking down, threatening the age-old tradition of families working in the same trade and thereby handing down skills.

Exposure to the media is another factor. As television reaches rural homes, different lifestyles and ways of dressing are seen.

Yet another is improved transportation. A new road to a village ends isolation and brings commercially made products to people who lived before by the work of their own hands. The *jumlo* of the remote valleys of Indus Kohistan vanished about twenty years ago, when the Karakoram Highway was constructed, opening up the valleys to the outside world.

Political events also play a role. The *phulkari* ceased being made when the enforced migration of Hindu, Sikh and Muslim, and their subsequent settlement in cities, ended the village women's way of life. It is social environment that sustains folk art.

So, as customs change, embroidery is threatened. Horses, whose regalia for marriage ceremonies was so lavishly embroidered, have been replaced by cars and scooters. Also, the bridegroom now likes to dress in a cheap Western suit, and prefers the bride to bring a

transistor radio and cash rather than embroideries as her dowry.

But all is not negative. The legacy of Gandhi, who promoted the handloom weaving of India as symbolic of the independence of its village life, and of hope for a future without colonial rule, lives on in government support for such work.

Tourism, too, though it diverts women from creating embroideries for status to making less elaborate versions for money, keeps alive a knowledge of stitches and techniques, which then stand a chance of being revived. The interest of Westerners can have a very positive effect. Journeying to some remote settlement just to look at a woman's embroidery, the reaction one provokes in her husband is at first disbelief, then pride. She, too, sees that she can sell really good work, and that the money for it is thrust into *her* hands, while her husband can only look on.

The revival of the *kantha* in the 1980s started with the commissioning of large pieces for a new 5-star tourist hotel in Dhaka and has continued under the auspices of several benevolent training schemes. The Crafts Council of India has also initiated training projects, thus reviving, for example, the embroidery of the Banjara. In Kutch similar projects exist, whereby women and their children are supported financially while they are trained to make embroideries that are not too far removed from their traditional textiles, and yet appeal to the tourist and export markets. Nonetheless, such embroideries will inevitably have lost their social and ritual significance and become merely articles for sale.

This is a phenomenon in no way unique to India and Pakistan, and it is unstoppable. For who could deny freedom of choice, of both husband and lifestyle, mobility, communication, and above all education, to that young girl who sits in front of a mud hut, needle through her nose as she pauses to insert the next stitch, silver hanging heavily round her neck, her clothes a blaze of colour like a gathering of hummingbirds — dress that enshrines her imprisoned past?

It is just such a blaze of colour that we feature in this book: embroideries from the collections of the British Museum, chosen not to be representative, but to astound by their visual impact. We have described the embroideries but not dated them, as traditions survive from generation to generation. Changes do occur — mostly the pattern becomes more crowded and the workmanship cruder, and new materials are introduced — but, unlike Western embroidery, in India and Pakistan the significant factor is that of village or tribe, not of decade or year.

Much of the beauty of India comes from poverty: even rags, plain unembroidered rags, can have a magical function. As India moves forward into a modern economy, its inspired tradition of folk embroidery is under threat, while that of Pakistan, its rural women still veiled and confined, may last a little longer. Just a little.

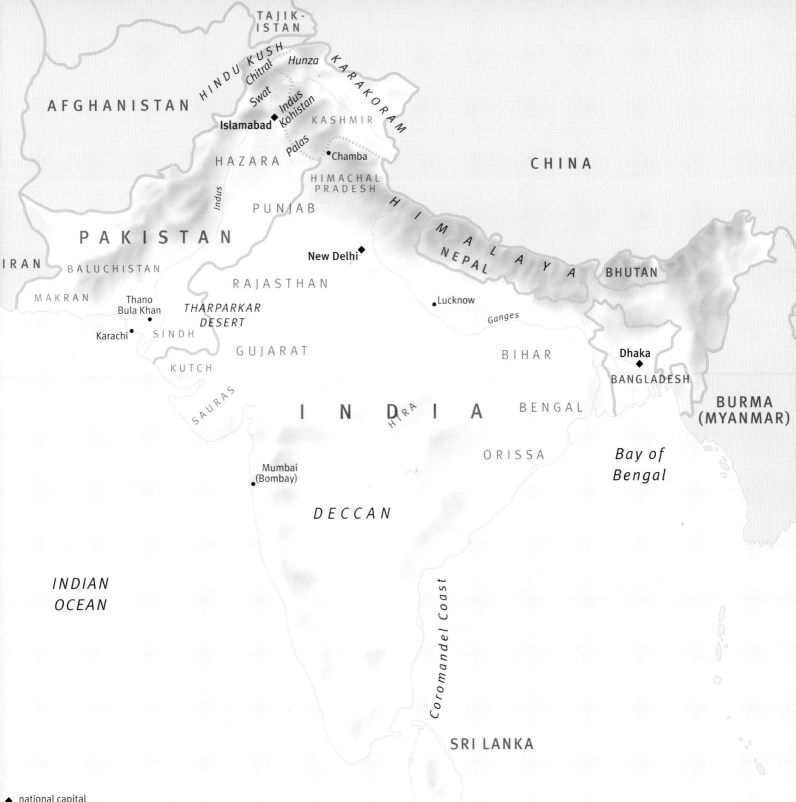

TAJIK-
ISTAN

HINDU KUSH

Chitral Hunza

KARAKORAM

Swat

AFGHANISTAN

Indus
Kohistan

◆ Islamabad

KASHMIR

CHINA

Palas

• Chamba

HAZARA

HIMACHAL
PRADESH

Indus

PUNJAB

H I M A L A Y A

PAKISTAN

NEPAL

BHUTAN

IRAN

BALUCHISTAN

New Delhi ◆

MAKRAN

RAJASTHAN

Thano
Bula Khan •

• Lucknow

Ganges

THARPARKAR
DESERT

BIHAR

Dhaka
◆

Karachi •

SINDH

GUJARAT

BANGLADESH

KUTCH

BENGAL

BURMA
(MYANMAR)

SAURAS

H
T
R
A

ORISSA

I N D I A

Bay of
Bengal

Mumbai
(Bombay) •

DECCAN

INDIAN
OCEAN

Coromandel Coast

SRI LANKA

◆ national capital

• city / town

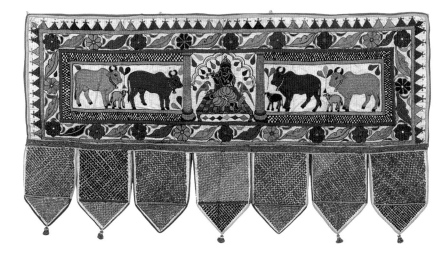

DOOR HANGING (*TORAN*)
These embroideries are hung above doorways on special occasions,
or over shrines. They are often complemented by side hangings, *sakhyo*.

Made of white cotton, this *toran* is embroidered in silk threads in herringbone
stitch outlined with chain stitch. The flower motifs are centred with *shisha* and the
borders are of appliquéd cotton strips. The main motif is of blue-faced Krishna
playing the flute. He is accompanied by the sacred cow, symbol of the
Mother Earth, which is often associated with him.
66 × 128 cm (26 × 50⅓ in)

THE VIVACIOUS MOTIFS OF HINDU SYMBOLISM ARE BALANCED BY THE FINE
GEOMETRY OF THE PENDANTS AND THE RESTRAINED SYMMETRY OF THE FLORAL
AND LEAF BORDER. THE LIVELY, BALANCED PALETTE OF RED, PURPLE, FUCHSIA,
GREEN AND YELLOW IS USED TO GREAT EFFECT.

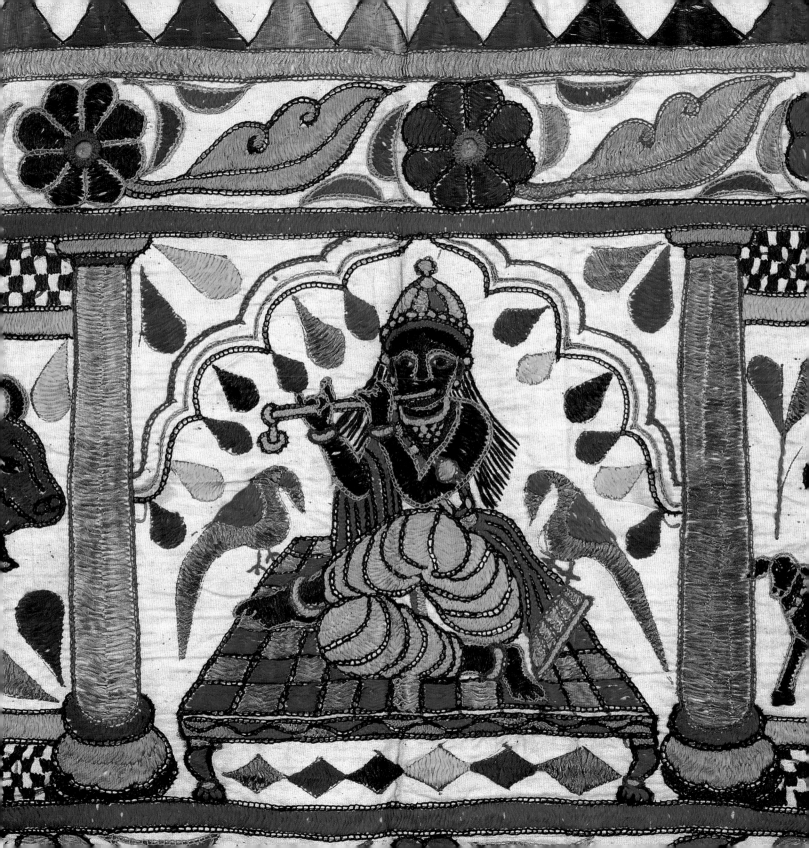

BAG

Small bags are a common article of domestic
embroidery in both India and Pakistan. They are used to hold
personal possessions ranging from the *Koran* to tobacco.

Made of natural cotton, this bag is entirely covered in stitchery —
mainly satin stitch, with dividing lines in open chain stitch worked in
yellow. The thread is silk and *shisha* mirror glass forms the centre of the
motifs and outlines the pattern division. There are additional silk
pompoms, some with central silver beads.
38.5 × 24 cm (15 × 9½ in)

A SIMPLE GEOMETRIC DIVISION IS WORKED TO SEPARATE THE
PATTERNING OF THE BAG INTO TRIANGLES, ENCLOSING FURTHER
GEOMETRICALLY BASED DESIGNS, IN PARTICULAR A STRONG BLACK
STAGGERED CROSS.

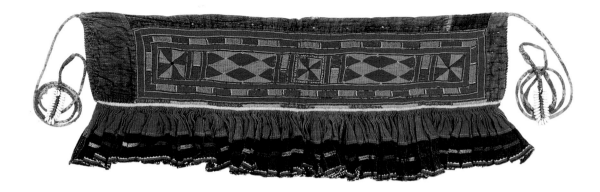

WAISTBAND OF A WOMAN'S SKIRT

Banjara skirts are made of horizontal bands of cotton and taffeta
stitched on to a very decorative waistband.

This waistband is of quilted indigo cotton, embroidered in dense
chain stitch with some buttonhole. Below it, two bands of the skirt remain,
one of brick-coloured pleated cotton and the other indigo, on which the
white cotton threads that attached the next band still remain.

35 × 95 cm (13¾ × 37½ in)

THE FORMALITY OF THE PATTERNS AND THE
FINE WORKMANSHIP OF THE WAISTBAND
CONTRAST WITH THE PLAIN FABRICS THAT WOULD

HAVE MADE UP THE SKIRT. THESE ARE OFTEN OF
POOR QUALITY AND ROUGHLY STITCHED
TOGETHER, HERE USING COARSE WHITE THREAD.

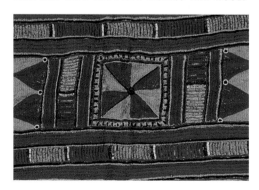

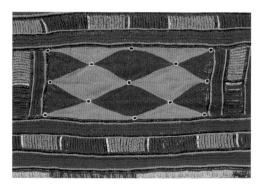

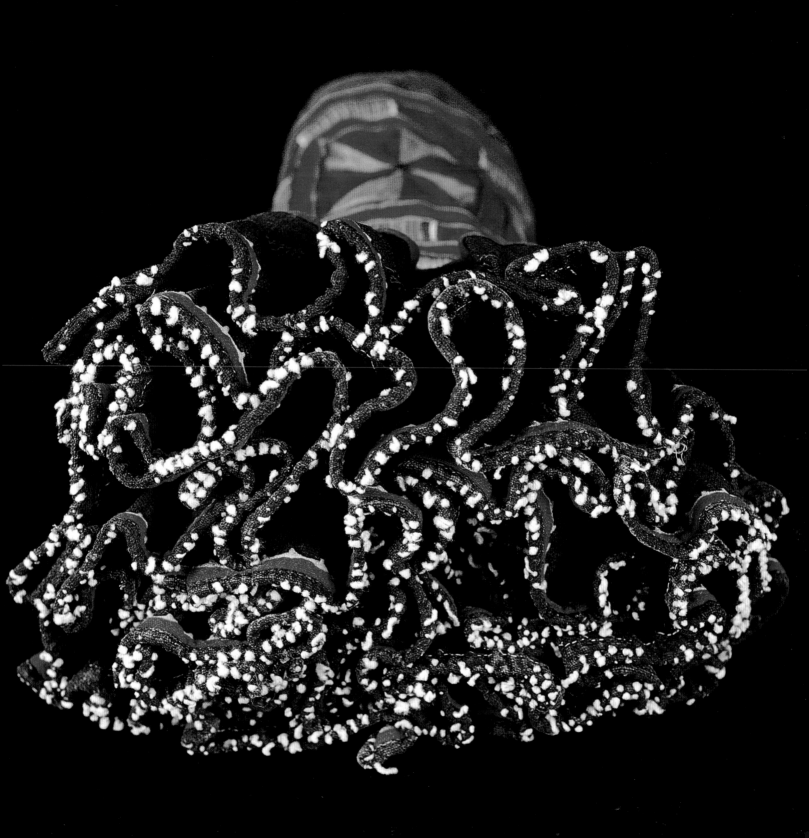

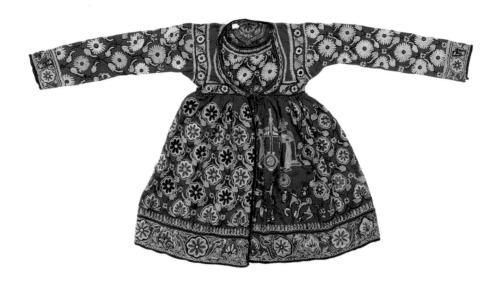

CHILD'S DRESS (*KEDIYA*)
Very lightweight red silk fabric is embroidered
with fine chain-stitch embroidery in typical Mochi style.
The bodice front is cut as a separate underpiece,
as in the traditional *angarkha*.
56.5 cm (22¼ in) × 105 cm (41 in) across arms

THE FIGURATIVE MOTIFS IN THIS EMBROIDERY ARE UNOBTRUSIVELY WORKED INTO A MORE FORMAL FLORAL PATTERNING THAT FEATURES THE LOTUS, SYMBOL OF THE SUN.

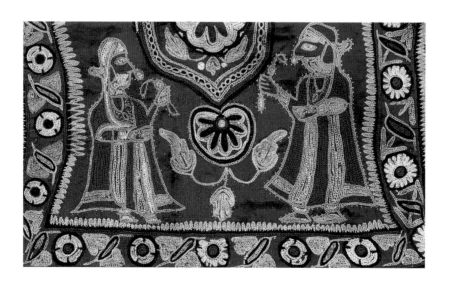

THE MOTIFS OF WOMEN CHURNING BUTTER (RIGHT), THE ELEPHANT AND THE HORSE (OVERLEAF) ARE ALL SYMBOLS OF PROSPERITY, CONSIDERED APPROPRIATE FOR THE CHILD'S FUTURE.

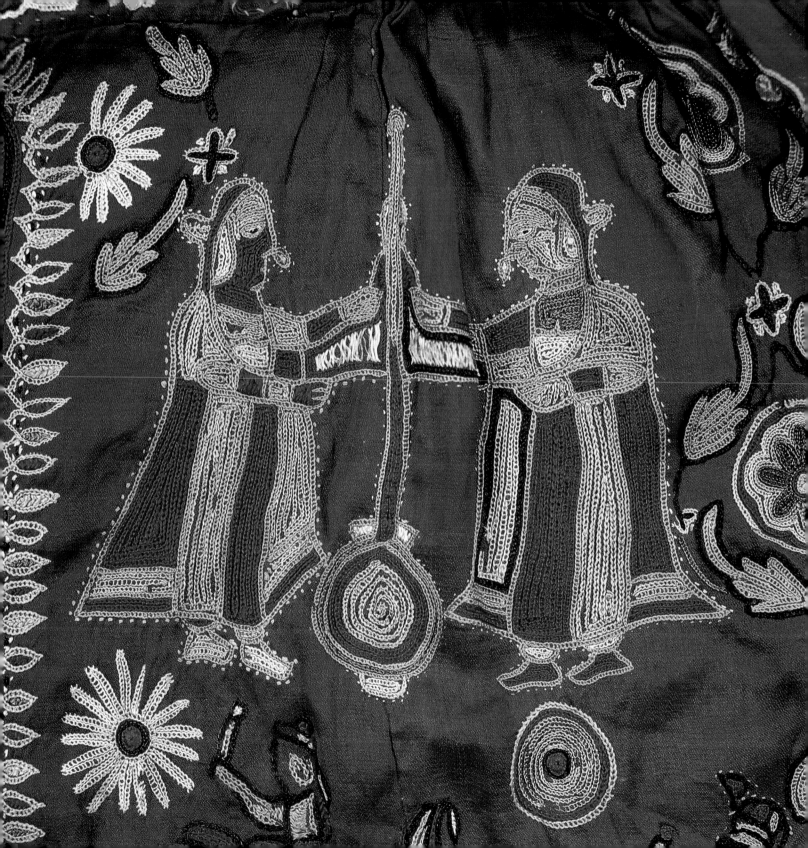

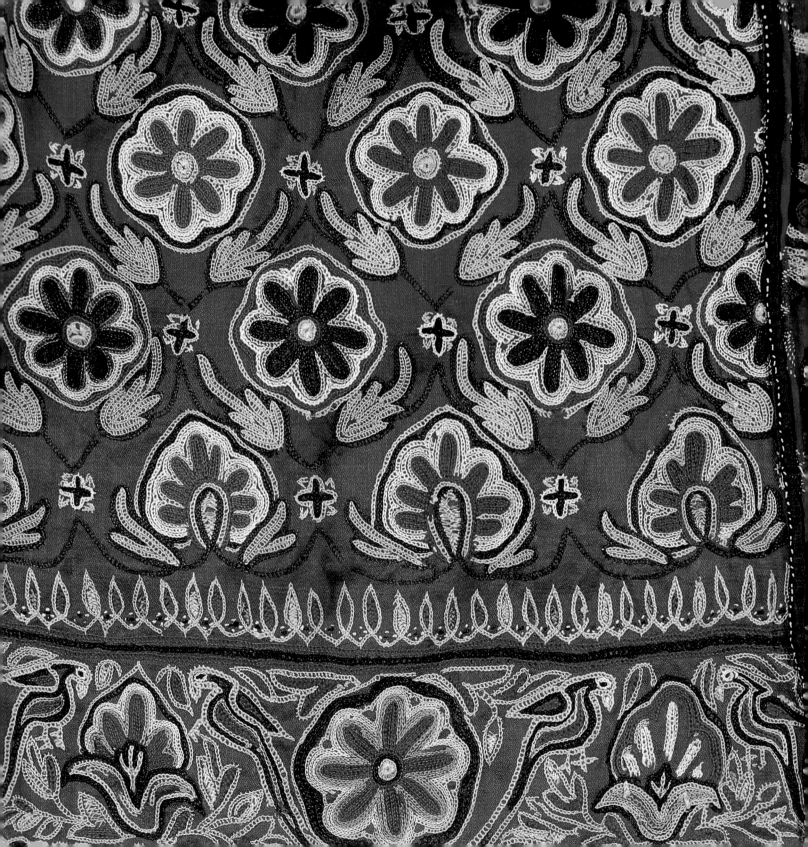

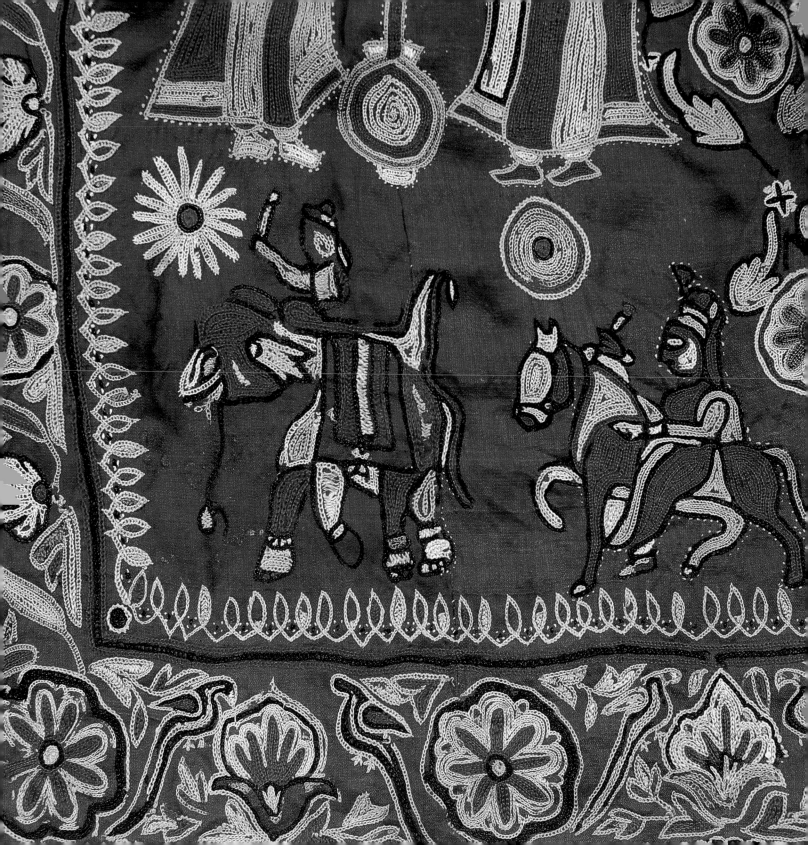

THE FORMALITY OF THE
BASIC DIAMOND DESIGN
IS GIVEN ADDED INTEREST
BY THE INTRODUCTION OF
A TRIANGULAR PATTERN
AT THE BOTTOM AND ALONG
ONE OF THE SIDES.

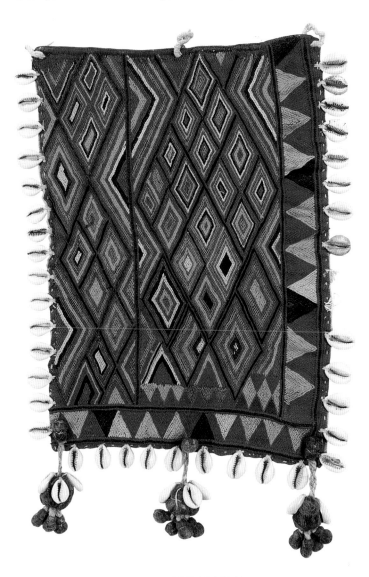

NECKPIECE (*GALLA*)
Neckpieces of this kind hang over the back of a
woman's head, protecting her nape from the strong sun.
They are usually attached to a padded ring on her head, called
an *indohni*, which enables her to carry heavy water-pots.

The cinnamon-coloured cotton is solidly embroidered in brick stitch, in
cotton thread. The edging of cowrie shells is traditional, and matted
pompoms of purple silk give added talismanic protection.
36 × 23 cm (14 × 9 in), including tassels and cowries

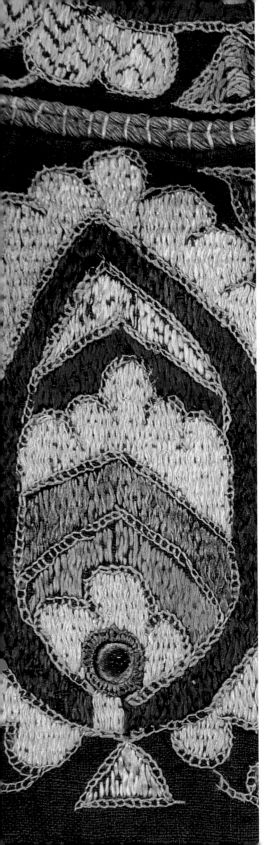
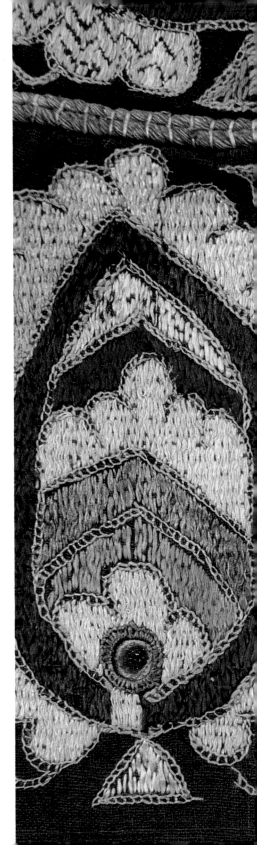

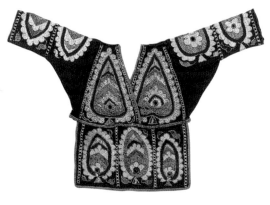

WOMAN'S BACKLESS BLOUSE

This style of blouse originates in the mountainous
north of India, close to Kashmir, and its patterning is
very different from the *cholis* of Gujarat.

The fabric is a coarse cinnamon-coloured *khaddar*,
cut in a straight panel across the lower front, with
straight panels for the sleeves, large square underarm
gussets and two shaped pieces for the front. The
embroidery is in straight stitch, outlined in chain.
One piece of *shisha* is sewn into the base of each
bush in the pattern, and into the centre
of the flowers on the sleeves.
41 cm (16 in) × 71 cm (28 in) across arms

THIS VERY UNUSUAL PIECE COMBINES A STRONG
REPEATED PATTERN WITH SUBDUED COLOURING.

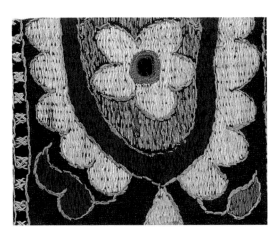

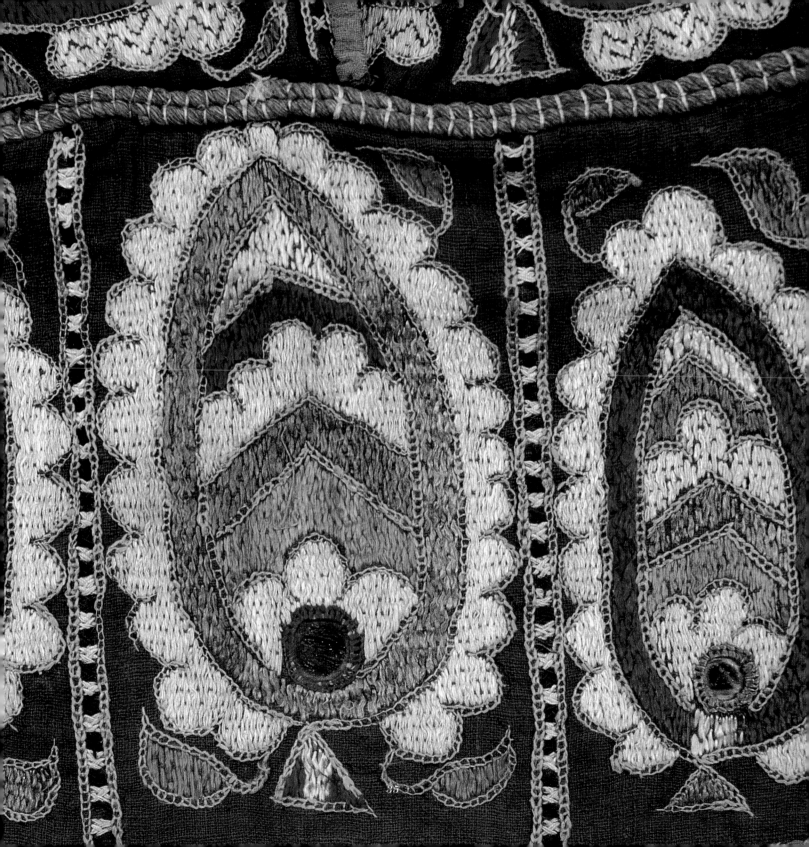

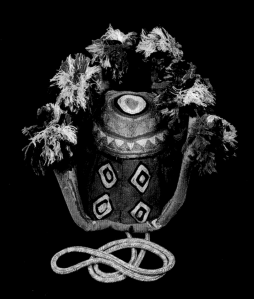

HAT

A most unusual cotton fabric hat
with a deep crown and rising flaps at
the side, which are padded with wool and
edged with large tassels. The embroidery is
entirely in chain stitch, with circles of colour
on the crown and black-and-white diamond
shapes at the front and on the flaps.
A cord loops under the chin.
27 × 15.5 cm (10½ × 6 in)
excluding tassels

A WONDERFUL EXAMPLE OF TEXTURE —
THE SMOOTH EFFECT OF THE CIRCLES ON
THE CROWN AND THE VERY ROUGH
TASSELS AROUND IT ARE PULLED TOGETHER
VISUALLY BY THE USE OF COLOUR.

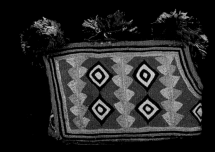

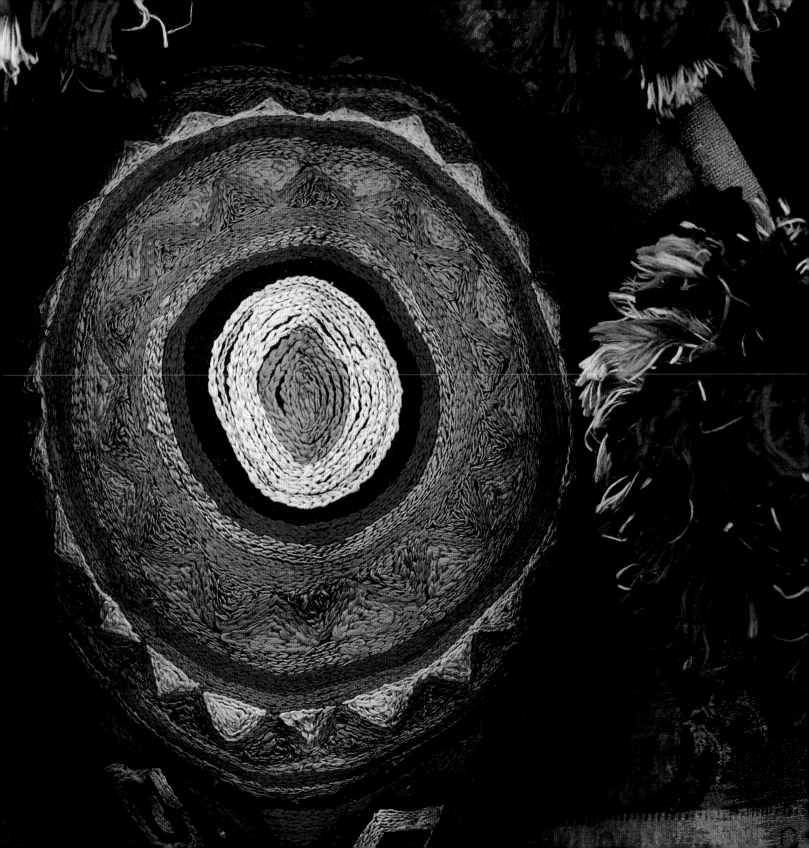

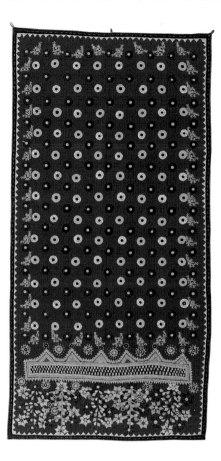

BEDDING COVER (*DHARANIYO*)
These decorative covers are used to protect
quilts piled up when not in use.

The cloth is made of very heavy, coarse brick-coloured
cotton, crudely embroidered in yellow, blue and white
cotton thread. Circles of radiating stitch are centred by a
spot of colour. The main field is separated from the border
of flowers by a row of small stylized peacocks, floral
motifs with *shisha* centres, and a multicoloured
band outlined by interlacing.
164 × 82 cm (64 ½ × 32 ¼ in)

THIS DESIGN SUCCESSFULLY COMBINES A STRONG GEOMETRIC
PATTERN WITH A HIGHLY DECORATIVE FLORAL BORDER.

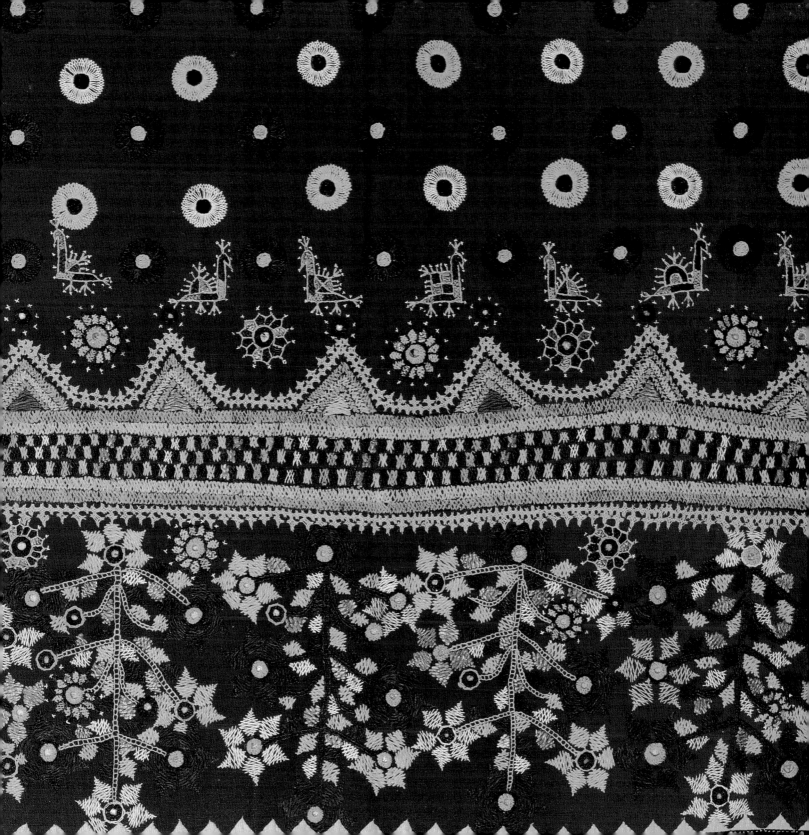

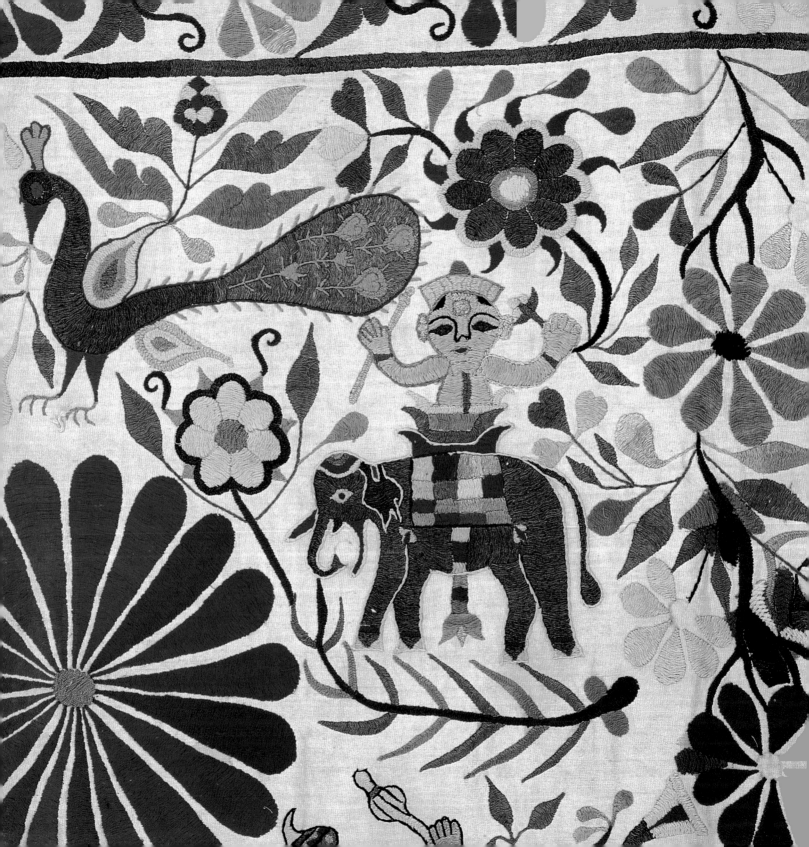

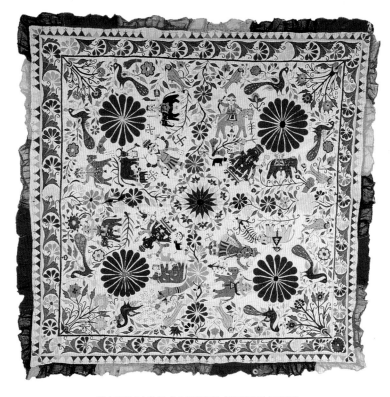

MARRIAGE CANOPY (*CHANDARVO*)
These canopies are erected outside the bride's home on the
occasion of a marriage, and sometimes even hung across the street.

The base fabric is plain white cotton, embroidered in multicoloured
cotton thread, mainly in herringbone stitch. The pattern features various
Hindu deities, including Ganesh the elephant god, remover of
obstacles and a favourite motif in household textiles.
180 cm (71 in) square

THIS PATTERN IS DIVIDED INTO FOUR SECTIONS REVOLVING AROUND A CENTRAL ROSETTE, WITH NO TOP OR BOTTOM. VIEWING IT FROM BELOW, THERE IS ENDLESS DETAIL TO BE ABSORBED. THE MOTIFS ARE HEAVY WITH SYMBOLISM FOR THE COUPLE, THE PEACOCK BRINGING FERTILITY AND HAPPINESS, AND BOTH THE ELEPHANT AND THE HORSE (SEE OVERLEAF) DENOTING PROSPERITY. THE ELEPHANT IS ASSOCIATED WITH LAKSHMI, GODDESS OF WEALTH.

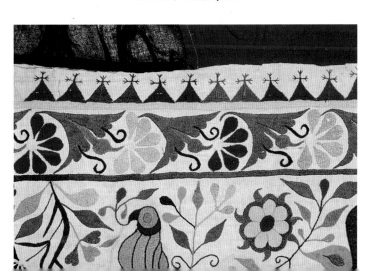

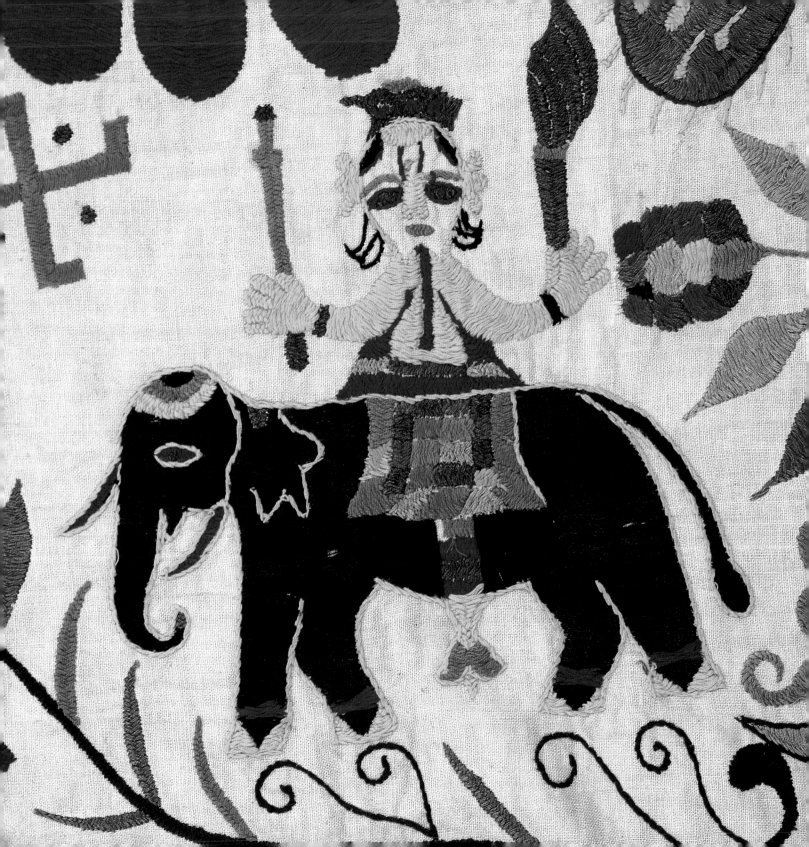

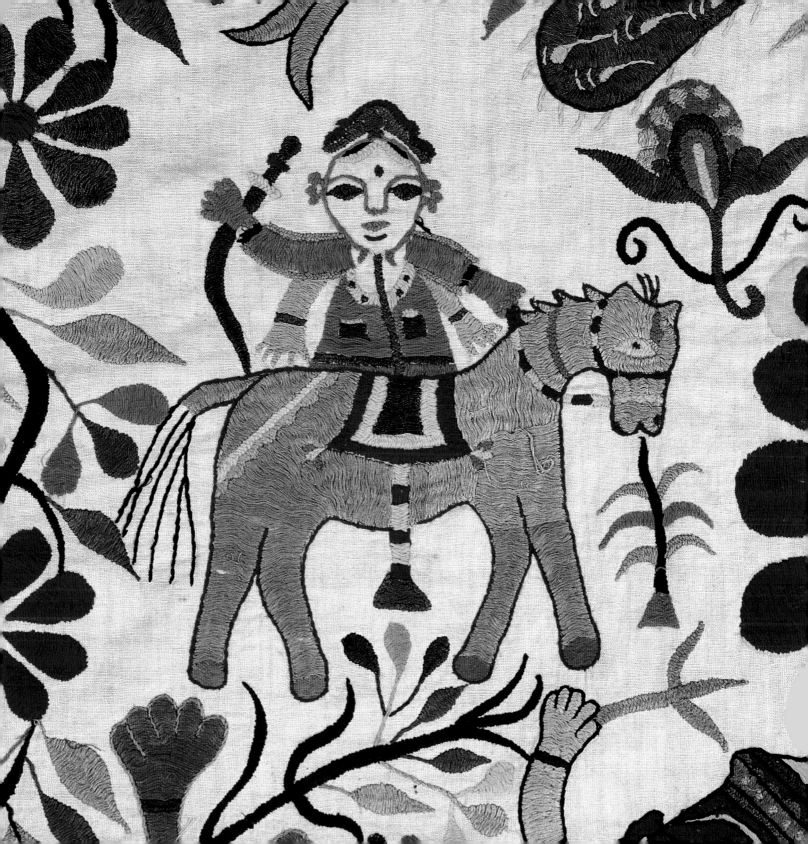

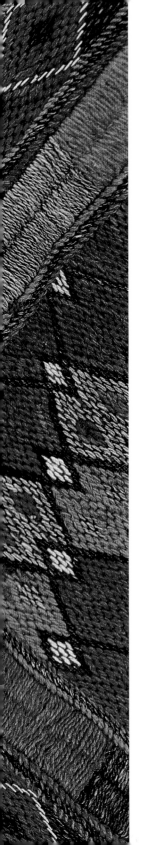
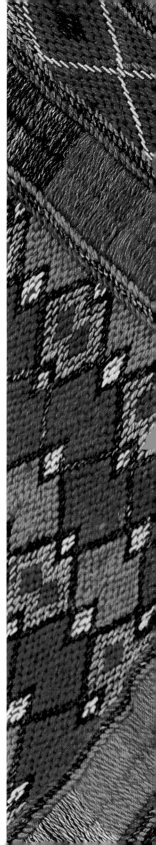

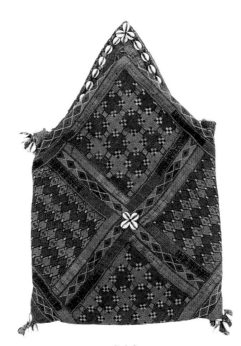

BAG

Bags were used for many purposes
by these semi-nomadic people, and were
usually envelope-shaped.

The fabric is a heavy natural cotton,
solidly worked in wool threads, mainly in brick
stitch. The corners and sides of the flaps are
decorated with small wool pompoms and
cowries on fabric rouleaux.
42 × 41 cm (16½ × 16 in)

THIS BAG HAS AN
UNUSUALLY LOVELY
COLOUR RANGE, THE
INTRODUCTION OF
GREEN ADDING TO
THE DEPTH OF
COLOUR ACHIEVED.

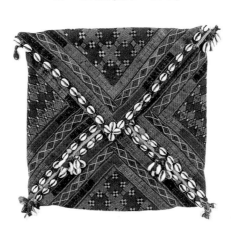

THE COWRIE SHELL
IS BELIEVED TO
HAVE PROTECTIVE
POWERS AND SO
FEATURES ON ITEMS
HOLDING PRECIOUS
OBJECTS.

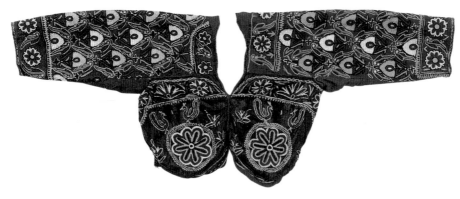

WOMAN'S BACKLESS BLOUSE (*CHOLI*)
Most women's costume throughout Kutch and Sindh
consists of a skirt worn with a backless blouse, the woman's
back being covered by an enveloping shawl.

This *choli* is made of lightweight silk fabric embroidered in very
fine chain stitch in the style of the Mochi. Two pieces of purple silk
form the front bodice, gathered to fit around the breasts, and
straight widths of red form the sleeves and side fronts. The drawn
design is unworked in some places and still visible.
32 cm (12½ in) × 84 cm (33 in) across arms

THE FORMAL STEP AND REPEAT DESIGN ON THE SLEEVES COMBINES WELL WITH THE MORE INFORMAL DESIGN ON THE FRONT. THE PEACOCK, A

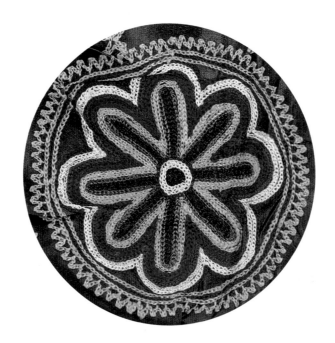

SYMBOL OF FERTILITY, IS APPROPRIATELY PLACED, AS THE MOTHER'S MILK IS ESSENTIAL FOR THE SURVIVAL OF HER BABY.

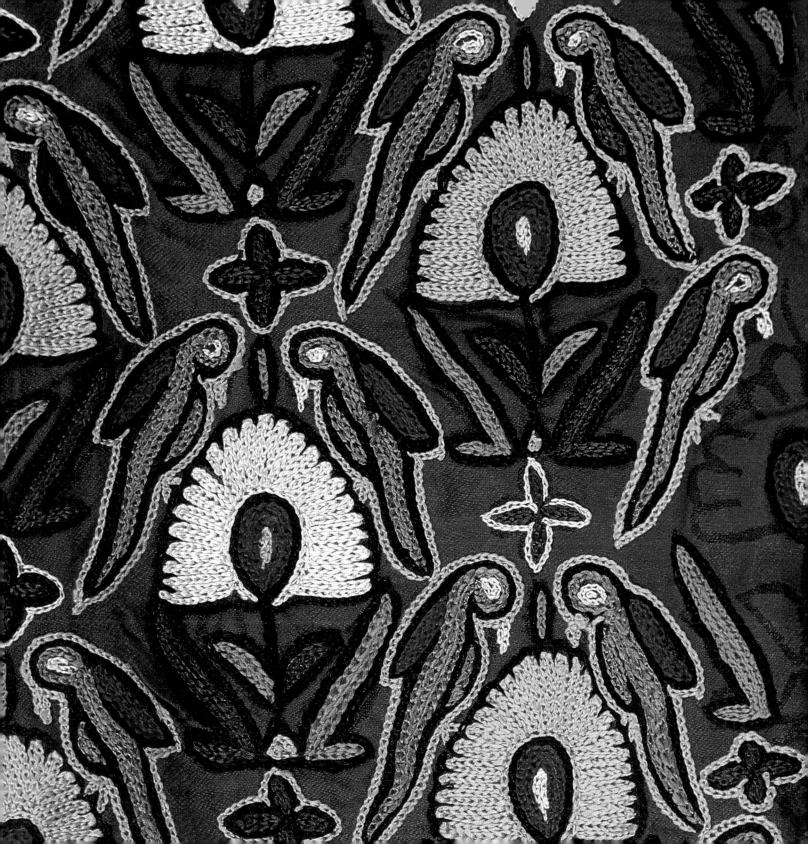

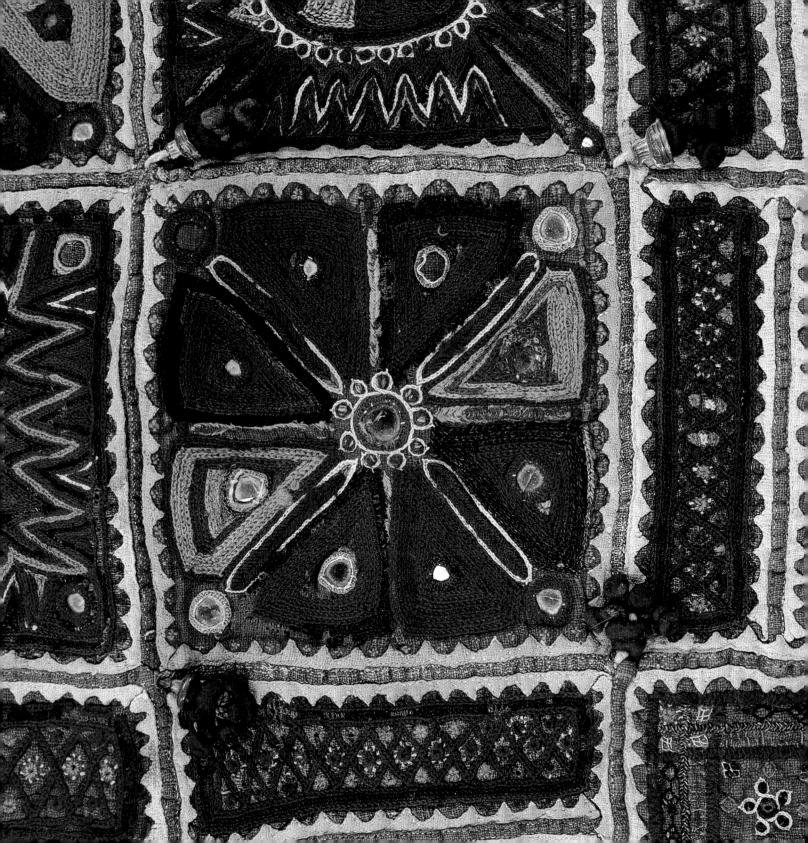

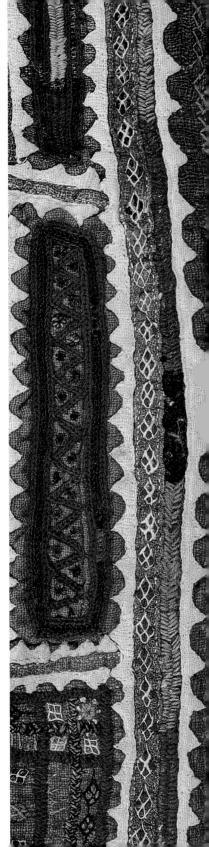

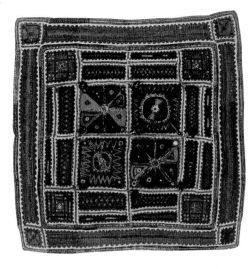

WEDDING MAT (*RUMAL*)
A small mat used to cover food
at marriage ceremonies.

The mat is made of a square of
natural-coloured cotton appliquéd with
patches of indigo- and brick-coloured cotton,
and with finer white cotton cut in a zigzag line.
The embroidery is mainly chain stitch in wool
thread, with some touches of fine white
cotton. The four larger central squares
are highlighted with *shisha*.
65 cm (25½ in) square

A PAINTERLY VIBRANCY IS
ACHIEVED THROUGH DEPTH OF
COLOUR ON A LIGHT GROUND.

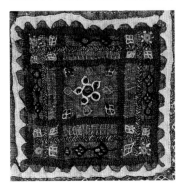

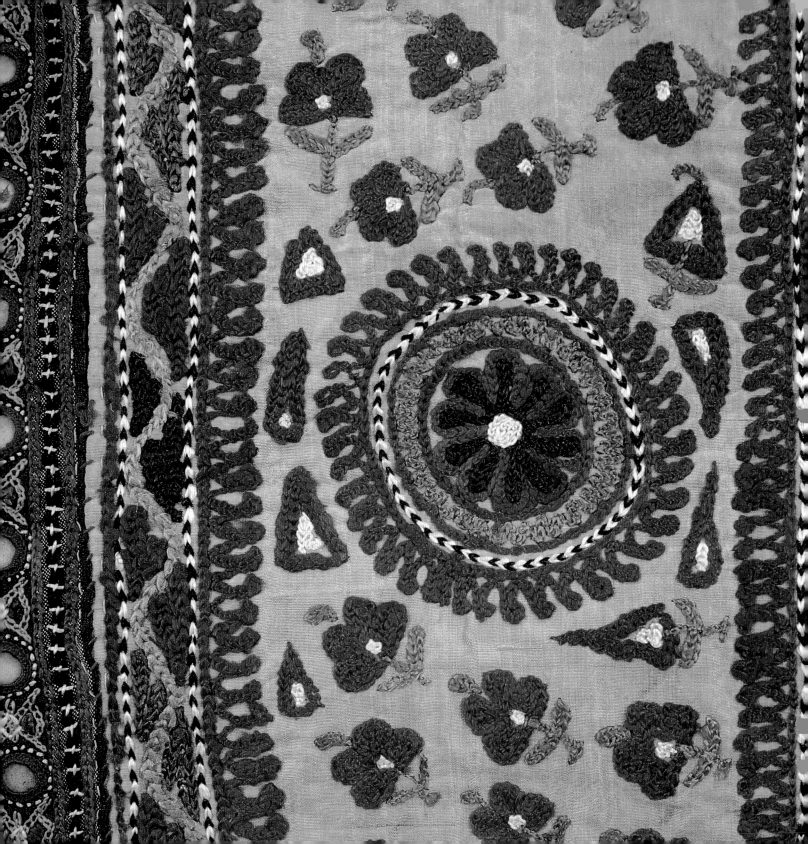

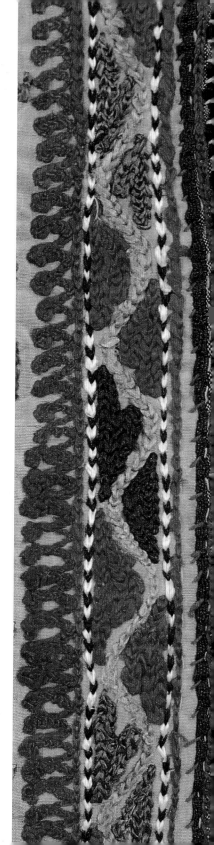

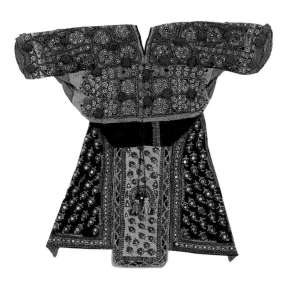

WOMAN'S BACKLESS BLOUSE (*CHOLI*)

This blouse is unusual in shape, in that the plain
central band gathers up to fit around the breasts, with
ties that end in tassels and cardamom seeds.

Pieces of fine silk are patched together
to form the blouse. The sides and bodice top are
entirely covered in *shisha* in a six-petalled floral motif,
enhanced by red silk pompoms. The embroidery
is in silk thread, mainly in chain stitch.
67 cm (26 in) × 75 cm (29½ in) across arms

THE SKIRT'S CENTRAL PANEL WITH ITS SIMPLE
MOTIFS AND BRIGHT YELLOW COLOUR STANDS OUT,
INTRODUCING VITALITY TO THE WHOLE DESIGN.

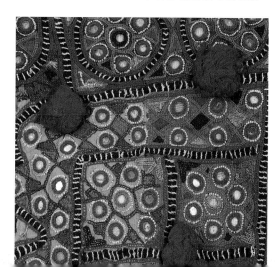

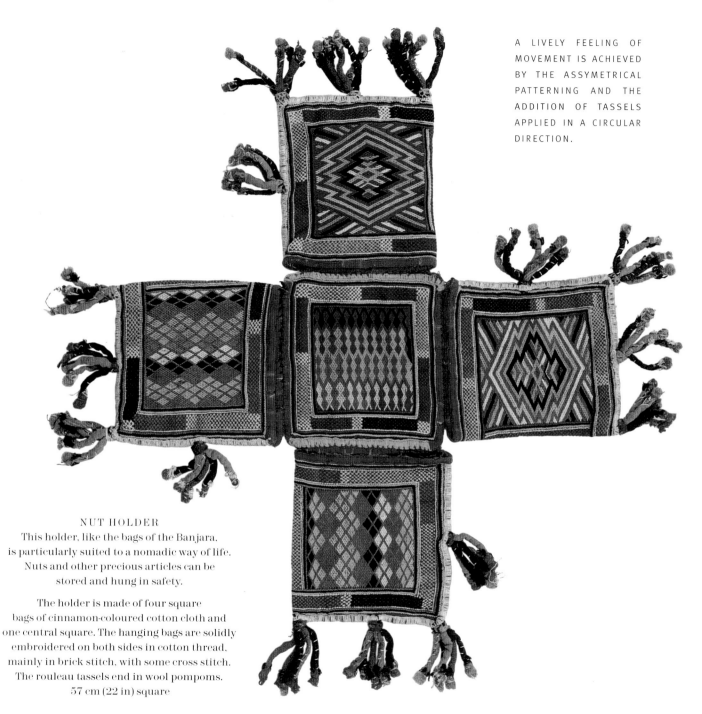

A LIVELY FEELING OF
MOVEMENT IS ACHIEVED
BY THE ASSYMETRICAL
PATTERNING AND THE
ADDITION OF TASSELS
APPLIED IN A CIRCULAR
DIRECTION.

NUT HOLDER
This holder, like the bags of the Banjara,
is particularly suited to a nomadic way of life.
Nuts and other precious articles can be
stored and hung in safety.

The holder is made of four square
bags of cinnamon-coloured cotton cloth and
one central square. The hanging bags are solidly
embroidered on both sides in cotton thread,
mainly in brick stitch, with some cross stitch.
The rouleau tassels end in wool pompoms.
57 cm (22 in) square

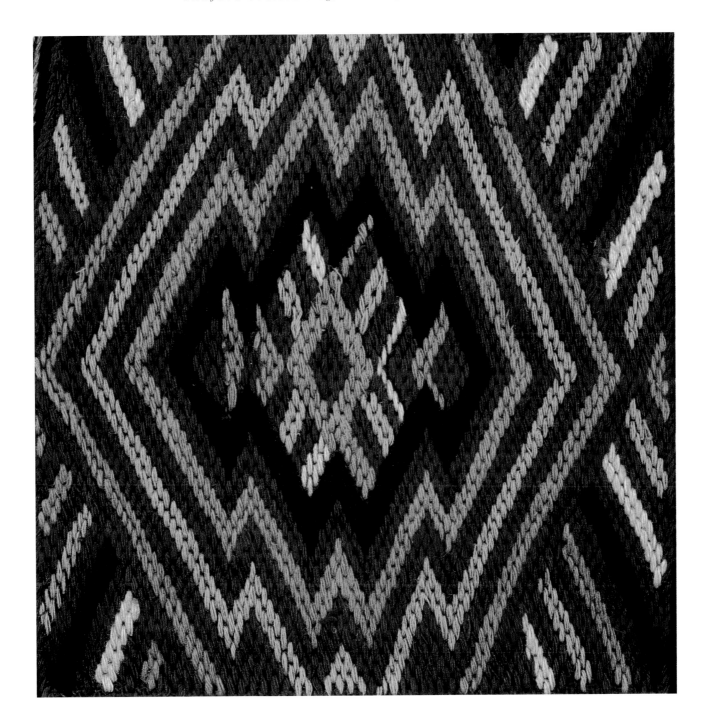

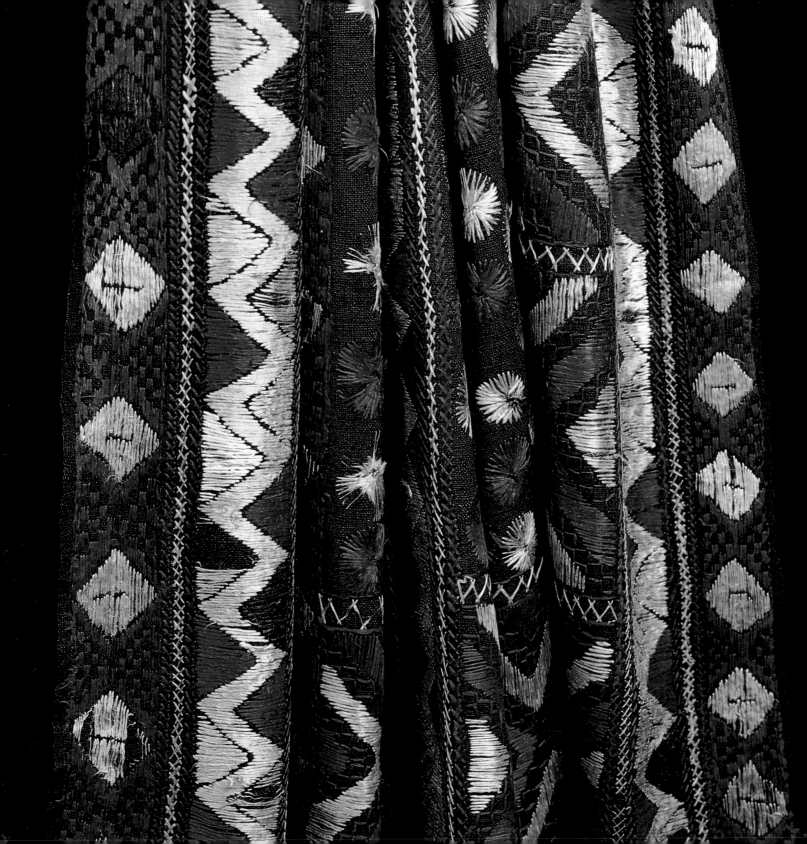

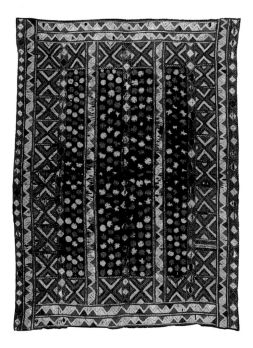

WOMAN'S SHAWL (*PHULKARI*)
The women's shawls of both eastern and
western Punjab are traditionally worked on
brick-coloured cloth (*khaddar*), with geometric
patterns in a darning stitch covering most
of the surface. Although indigo fabric is
also used, black is unusual.

This embroidery is done in floss silk, a
weak thread that wears easily. The stitches
used are surface darning, worked from the
back of the fabric, and radiating
stitch for the circular motifs.
165 × 133 cm (65 × 48 in)

THE OVERWHELMING USE OF
GOLDEN-YELLOW AND RED ON
A BLACK BACKGROUND IS
ENLIVENED BY OCCASIONAL
TOUCHES OF DEEP PURPLE.

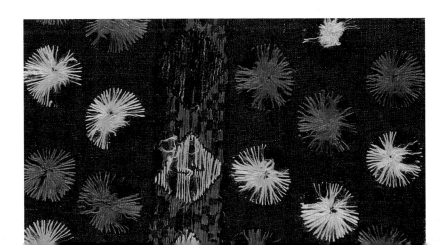

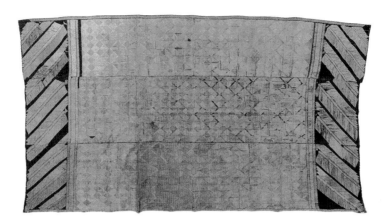

WOMAN'S SHAWL (*BAGH*)

These shawls were begun by the grandmother at the time
of a child's birth. If a girl, she would wear it at her marriage.
If a boy, it would drape his bride. In the *phulkari* tradition,
when these shawls are almost completely covered with
stitchery they are known as a *bagh* (garden).

Loosely woven, cinnamon-coloured cotton (*khaddar*) is
worked in surface darning stitch from the back. The thread is
yellow floss silk, and normally a small touch of contrast is
added — in this case, a patch of deep brownish-red.
245 × 133 cm (96½ × 52 in)

THIS SHAWL, WITH ITS RESTRAINED DUOTONE, DEPENDS ENTIRELY
FOR ITS EFFECT ON THE PLAY OF LIGHT PERMEATING THE DESIGN
WITH AN AUSTERE BEAUTY.

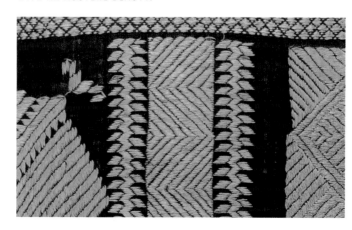

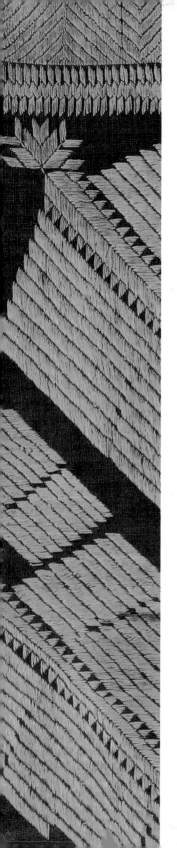

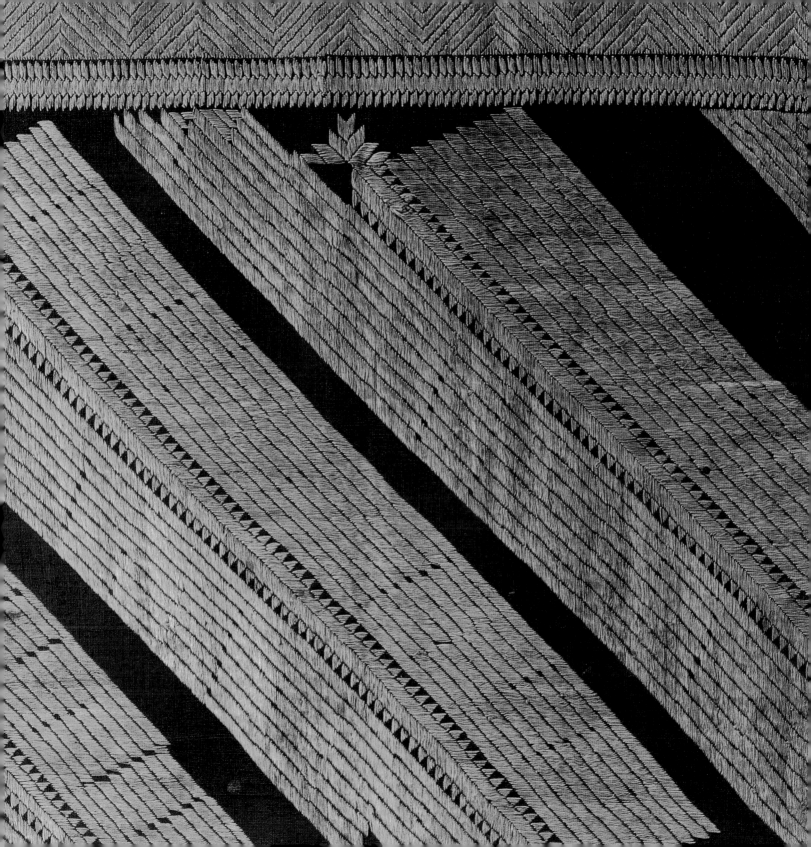

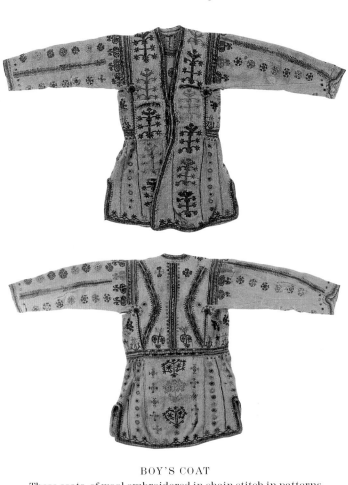

BOY'S COAT

These coats, of wool embroidered in chain stitch in patterns
that recall the *numdah* rugs of Kashmir, are still worn every day
in many high valleys of northern Pakistan, although their rich decoration
would seem to indicate that they are garments for special occasions.

This coat is made of narrow strips of densely woven and fulled natural-
coloured wool, embroidered in chain stitch in woollen thread, mainly
in brown. There is an inner flap behind the front opening,
and a gap under the arm instead of a gusset.
90 cm (35 in) × 160 cm (63 in) across arms

THE PRIMEVAL FORCE OF THE PATTERN SITS WELL ON THE MUNDANE
WOOLLEN FABRIC. THE MOTIFS USED ARE DEEPLY SYMBOLIC. THEY
INCLUDE VERSIONS OF THE TREE OF LIFE (OPPOSITE), SOLAR
PATTERNS AND RAM'S HORN PATTERNS (SHOWN OVERLEAF), ALL OF
WHICH ARE COMMON TO CENTRAL ASIA.

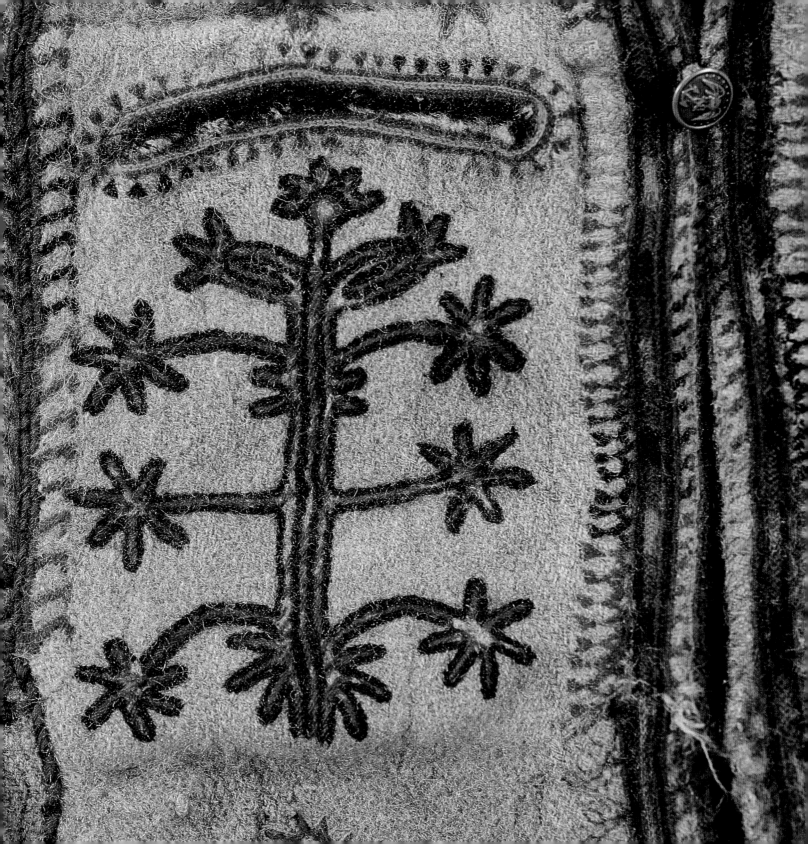

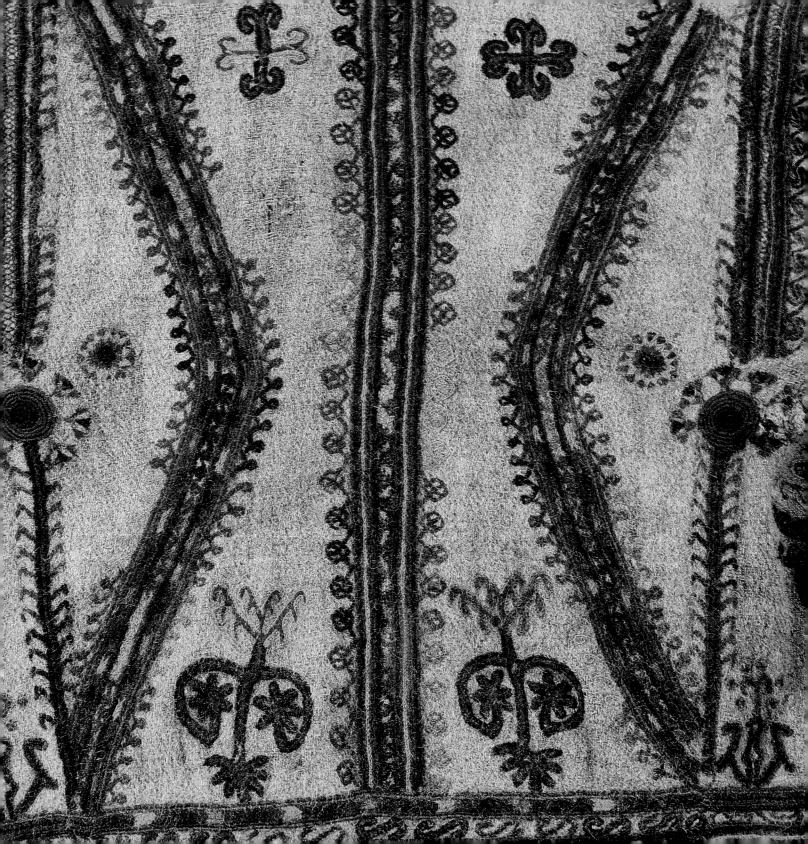

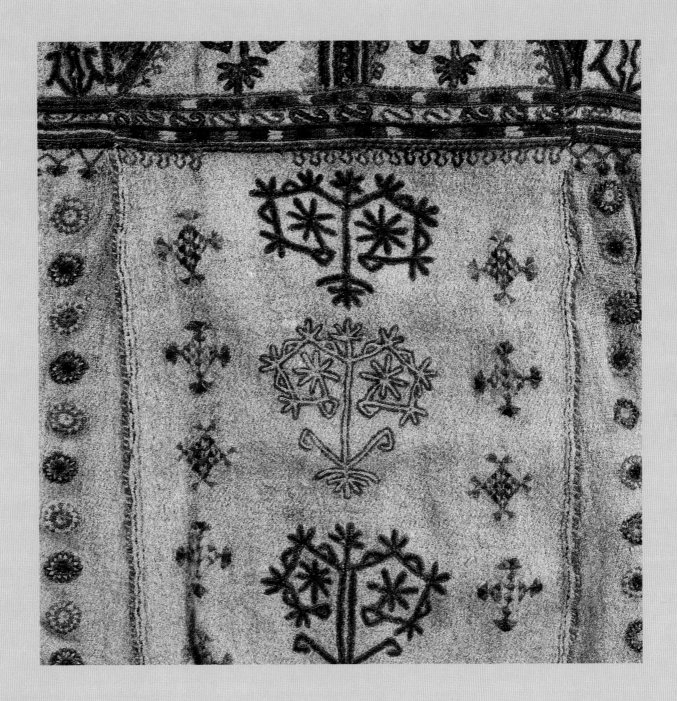

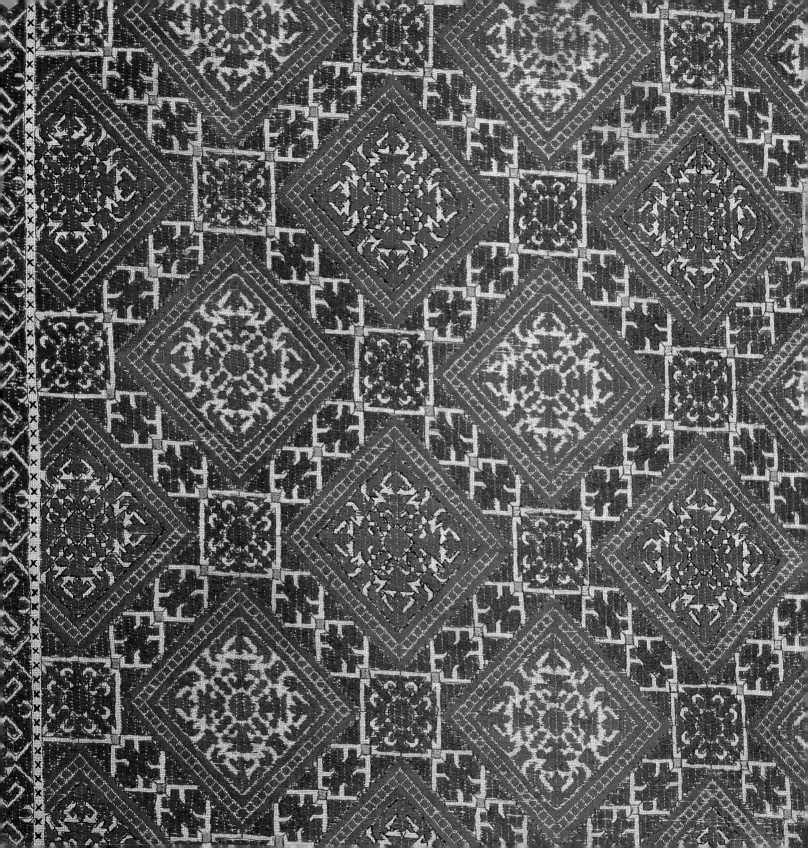

THE FAULTS SEEN IN THE
CENTRAL PATTERN, WHERE
THE JOINED STRIPS ARE
BADLY ALIGNED, BRING IT
ALIVE.

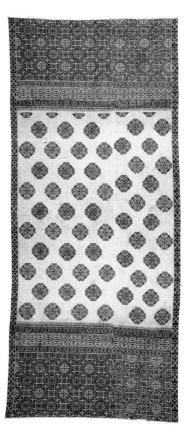

WOMAN'S SHAWL

These embroideries show the influence of both the *phulkaris*
of Punjab, further to the south, and the shifts of Swat Kohistan to the north.

The shawl is made of two uneven widths of white cotton, embroidered in a design of
diamond shapes filled with complex patterns with contrasting outlining. The embroidery
is in pink, like that of Swat Kohistan, but includes a greater range of shades and is
worked on white instead of black. The patterns are also more intricate.
263 × 111 cm (103½ × 43¾ in)

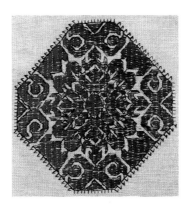

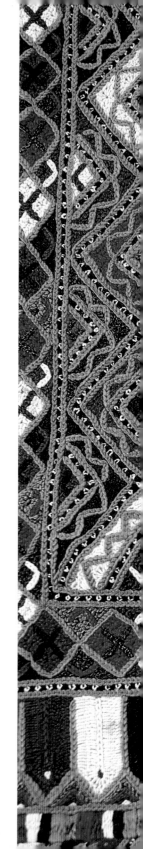

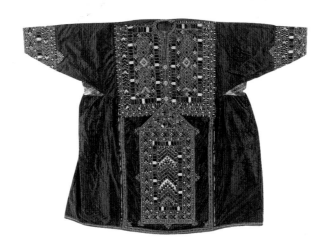

WOMAN'S DRESS (*PASHK*)

A woman's dress of the Baluchi people from near the Afghan border.
The bodice front is densely embroidered, as is the *pudo*, a pocket extending
from the hem to an upward-pointing triangle over the genital area.

The dress is constructed of rectangles of fabric, with shaped sleeves and
a contrasting underarm gusset of brocaded silk. The linear division of the
embroidery, using rows of chain stitch and black threads couched in white,
extends into a wider band of patterning over the breast. The hem and
seams are worked in red interlacing and orange herringbone.
108 cm (42½ in) × 146 cm (57½ in) across arms

THE RICHLY BOLD PALETTE OF BALUCHI EMBROIDERY IS USED HERE AGAINST A GROUND OF PURPLE SILK. AN EXCITING EFFECT IS CREATED BY THE STRICT DIVISION OF THE DESIGN INTO CONTRASTING AREAS OF DENSELY WORKED EMBROIDERY AND PLAIN FABRIC, TYPICAL OF BALUCHI WORK.

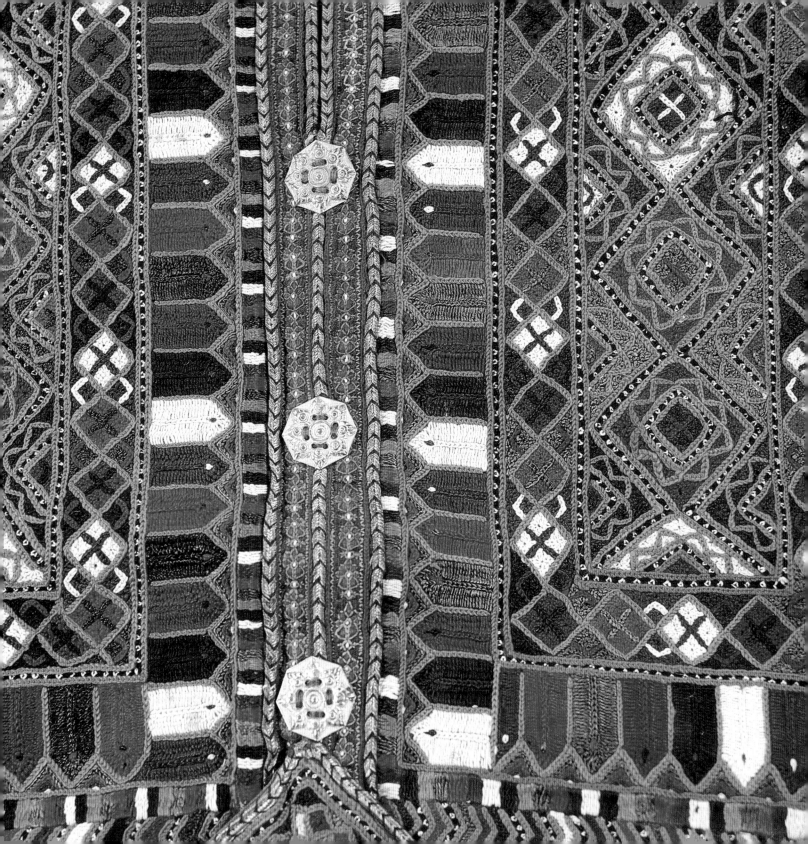

MAN'S MARRIAGE SCARF (*BOKANO*)
Such scarves were given by the bridegroom's
future mother-in-law and worn by him
at his marriage, wrapped around the
chin and over his turban.

Two narrow lengths of fine red cotton are
joined by intricate faggotting. The embroidery
is exquisitely fine satin-stitch counted-thread
work with some interlacing, in silk thread. The
geometric patterns are those that result from
counted thread — triangles, stars, diamonds,
chevrons — but also include a stylized
peacock on a flowering bush.
18.5 × 162 cm (7¼ × 63¾ in)

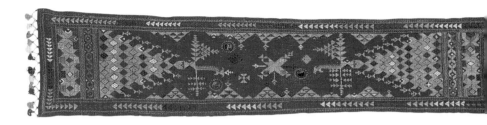

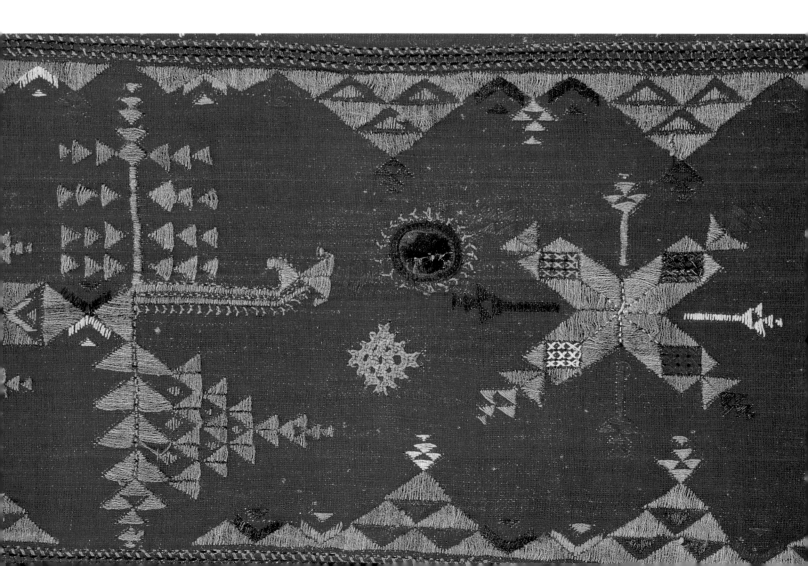

suthar group, tharparkar, sindh, southern pakistan

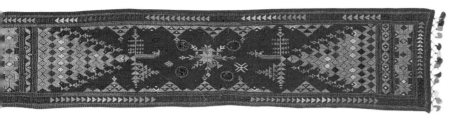

THIS APPARENTLY FORMULAIC DESIGN IS ON CLOSER INSPECTION SEEN TO BE FILLED WITH SMALL AND QUIRKY VARIATIONS. THE IRREGULAR USE OF THE COOL GREY-GREEN COLOUR FROM END TO END DOES IN FACT PROVIDE THE FRAMEWORK INTO WHICH ALL THE REMAINING ELEMENTS SENSITIVELY FALL.

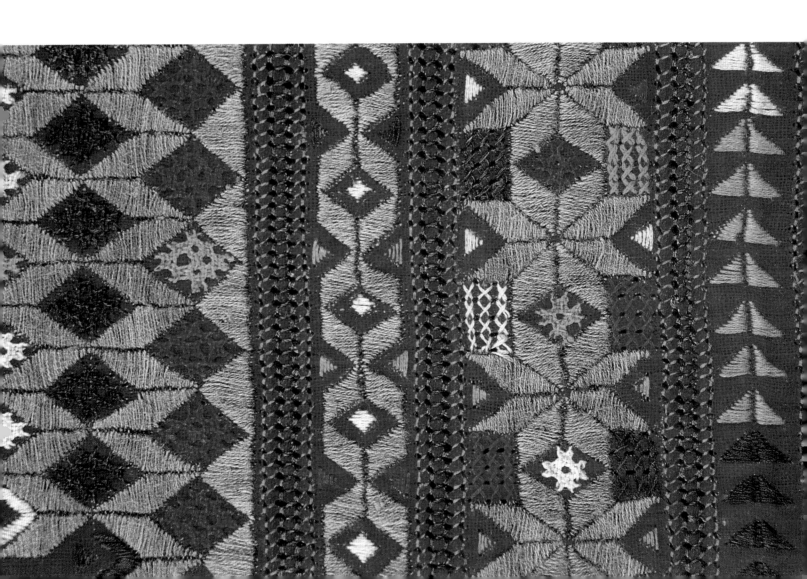

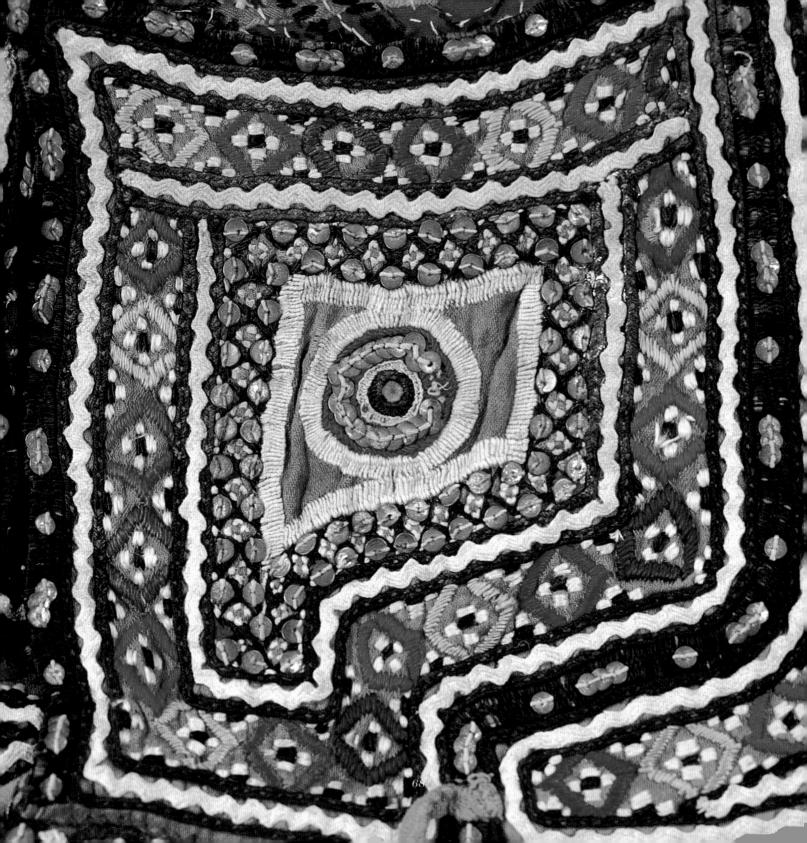

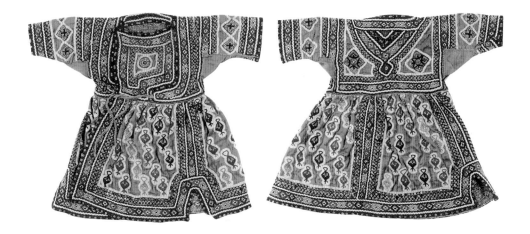

CHILD'S JACKET (*KERIYA*)
Beautiful jackets such as this were commonly worn
by small children throughout north-west India and Sindh.

The motifs on this jacket, which is made of orange
silk, are embroidered mainly in buttonhole stitch and
radiating stitch, in silk threads. The borders and dividing
lines are edged with commercial ricrac and accentuated
with sequins. There is one central *shisha* on the front
and two on the back: one at the nape
and the other at the waist.
52 cm (20½ in) × 56.5 cm (22¼ in) across arms

THE DESIGN IS AT ONCE FORMAL AND FREE-FLOWING, ALLOWING THE PRACTICALITIES
OF THE DRESS SHAPE TO INFLUENCE THE PATTERNING.

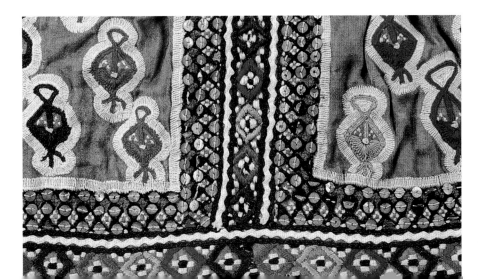

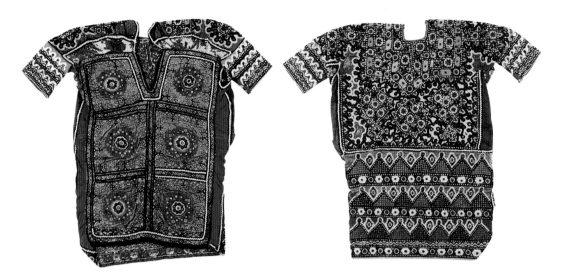

WOMAN'S SHIFT (*GUJ*)
Thano Bula Khan is a Hindu enclave in the Sindh desert.
The women's shifts are still made, and worn on special occasions.

The dress is made of pieced fabrics cut in straight sections. The back is
always divided horizontally into two different sections, and is different
again at the front. There are inserts of taffeta down the sides, and the
sleeves are narrow and straight. The embroidery is dense, mainly
in buttonhole and straight stitch in thick silk thread.
95 cm (37½ in) × 105 cm (41 in) across arms

THESE SHIFTS DEMONSTRATE THAT DISPARATE ELEMENTS, HOWEVER COLOURFUL,
DO NOT ALWAYS ADD UP TO A SUCCESSFUL DESIGN.

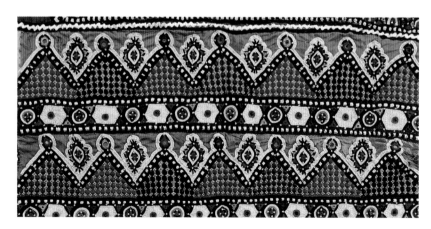

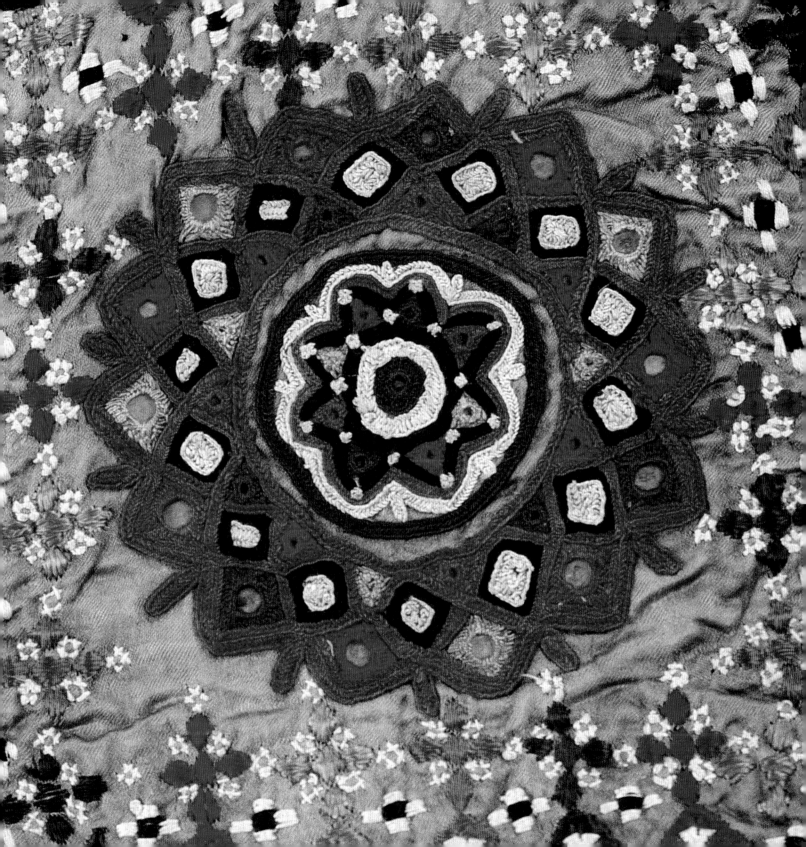

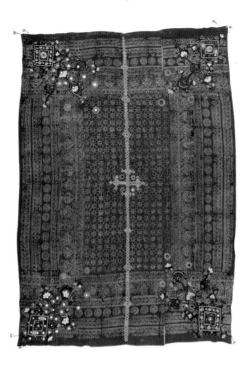

MAN'S WEDDING SHAWL (*MALIR*)

These shawls were made by the bride for her groom. The stylized peacock,
which appears in each corner, symbolizes fertility and was a favourite motif.

The shawl is made of fine red resist-printed cotton of two unequal widths. The embroidery
is in open chain stitch in silk thread at the corners and down the central seam, with some *shisha*
randomly placed. On each corner there is a pair of tiny tassels with small pompoms, shells and
beads. The variation of the square motif at the corners, worked in either interlacing or satin
stitch around a central white 'rayed sun', or dark red cross, adds vibrancy to the design.

180 × 132 cm (71 × 52 in)

AN ORNATE RESIST-PRINTED
BACKGROUND FABRIC IS
OVER-EMBROIDERED WITH
PATTERNS THAT MIGHT BE

EXPECTED TO CLASH WITH
IT, AND YET THE RESULT
IS A RICH, HARMONIOUS
DESIGN.

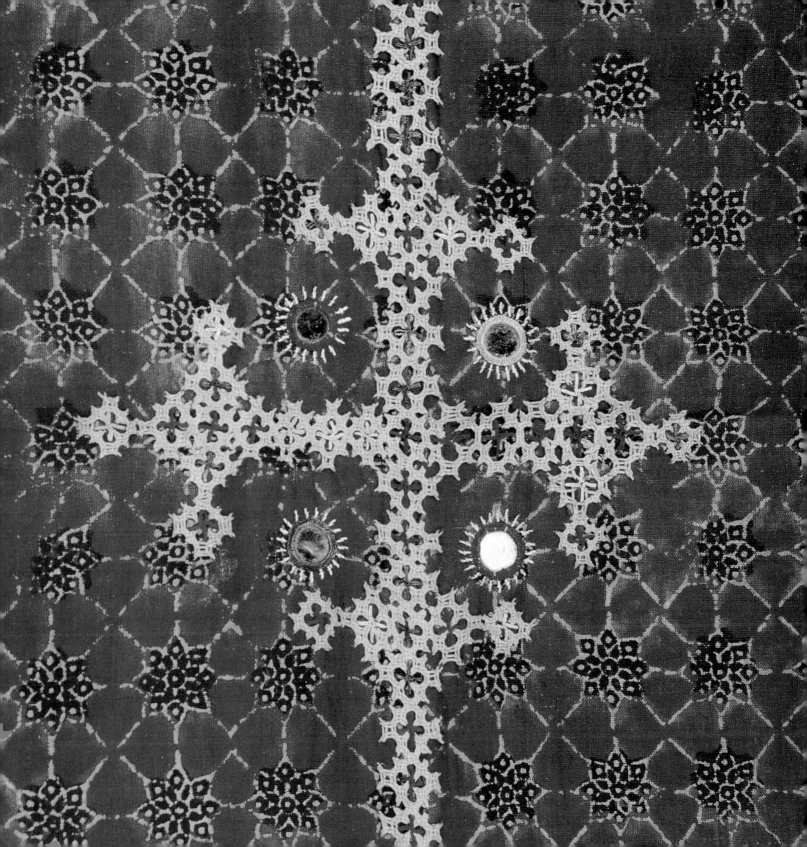

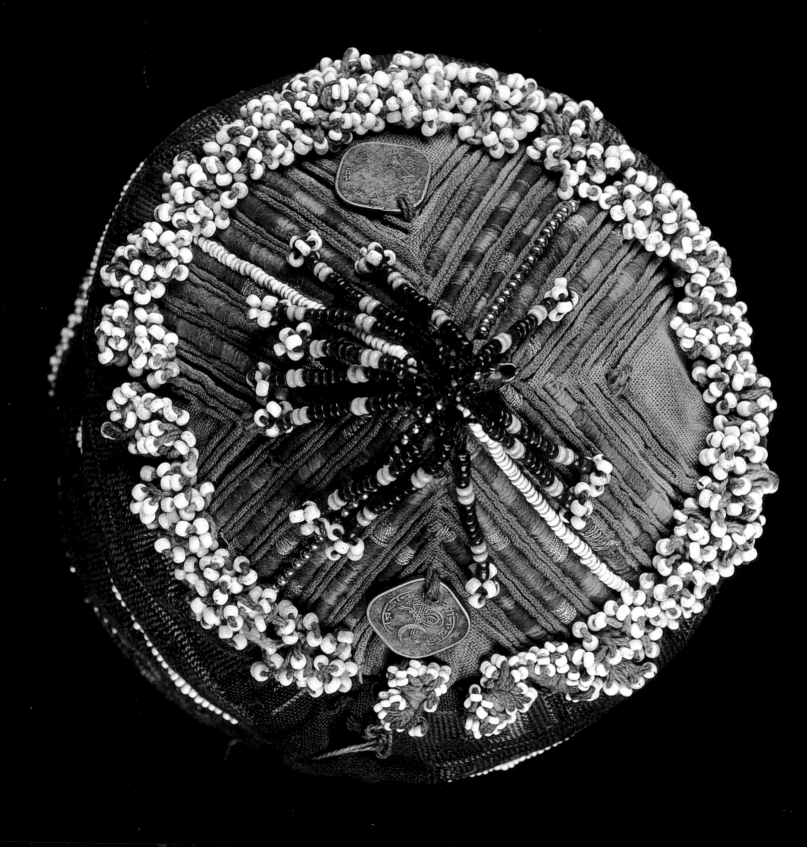

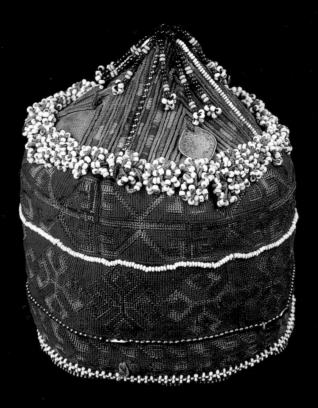

CHILD'S HAT
Various styles of hat and helmet are still
worn by children in the high valleys of Indus Kohistan.
The embroidery techniques (a combination of tent
stitch and white beads) are typical of this region.

The raised part of the crown is achieved by
inserting slivers of wood into grooves made by stitching.
Patterns are variations of the cross motif and are solidly
worked in silk threads. One side of an old zip forms
the bottom edging, while small lengths of chain
decorate the crown and encircle the cap.
depth 20 cm (8 in)
circumference 17 cm (6⅗ in)

THIS CAP USES NATURAL COLOURS WITH THE BOLD
INTRODUCTION OF WHITE BEADING AS A DIVIDING
ELEMENT, BOTH CIRCULAR AND LINEAR. COINS ARE
A DEVICE WITH AMULETIC POWER TO PROTECT THE
CHILD, AS ARE PIECES OF CHAIN AND ZIPS.

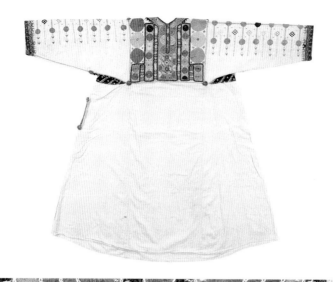

WOMAN'S DRESS

Long dresses of this type were worn in Sindh and by the
Bugti and Brahui of Baluchistan. The contrasting underarm
gusset is typical of the region right through to Afghanistan.

This dress of white cotton is very finely embroidered in silk threads
of pastel colours, in radiating stitch with some chain and herringbone.
Pink silk fabric, flanked by yellow, is appliquéd at the neck and outlined
with a row of black threads couched in white. Circular patterns in
radiating stitch are a feature of Sindhi embroidery.
112 cm (44 in) × 134 cm (52¾ in) across arms

LIMITING THE PALETTE TO SOFT PINKS AND YELLOWS AND THE DESIGN TO ALMOST

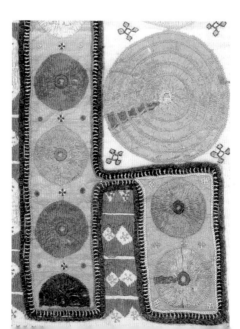

ENTIRELY CIRCULAR SHAPES IMBUES THIS EMBROIDERY WITH A DELICATE SUBTLETY.

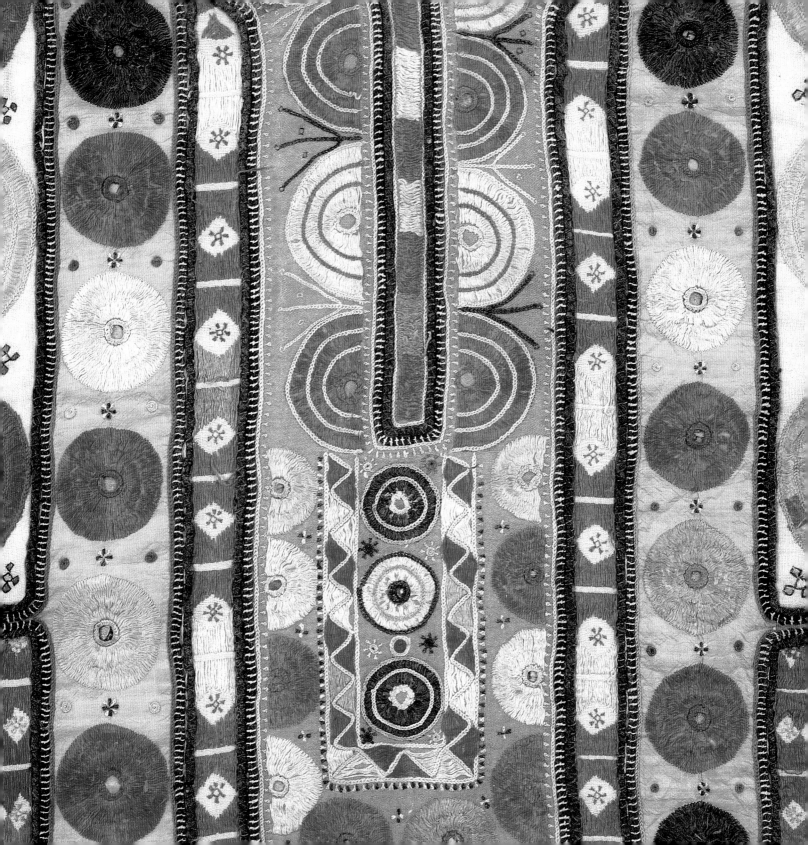

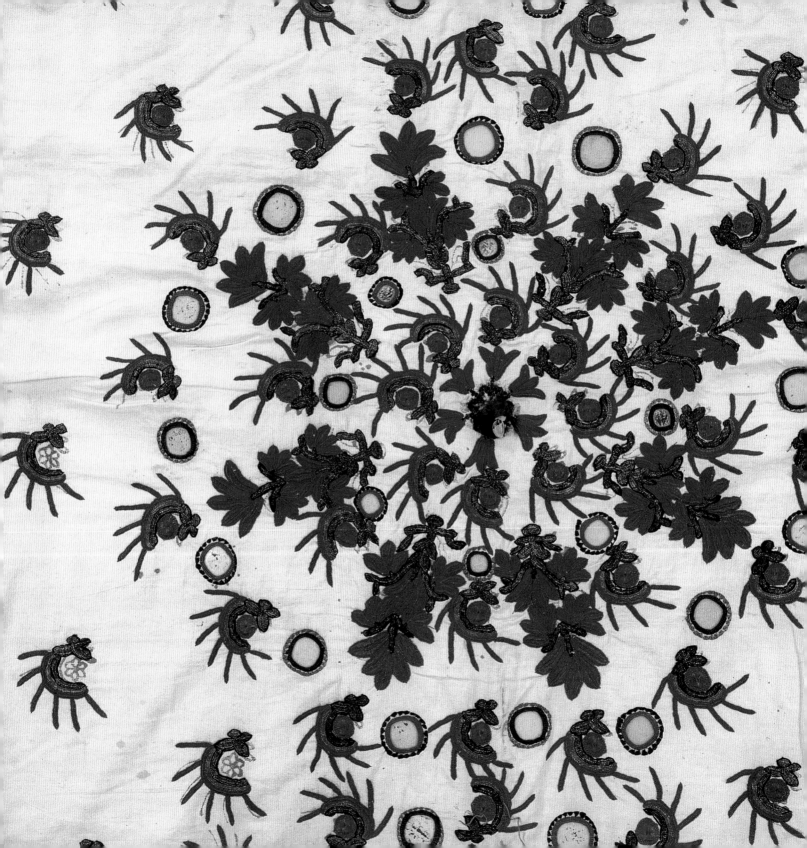

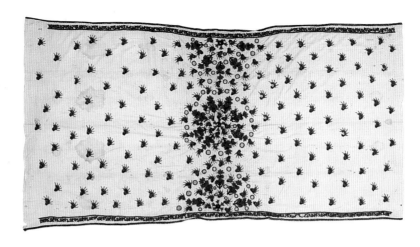

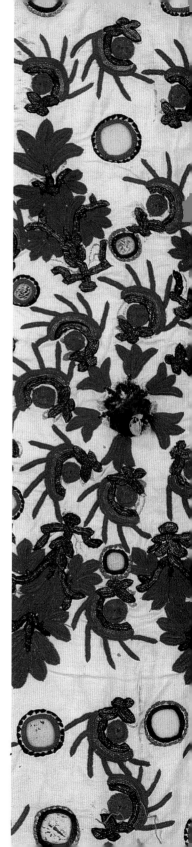

WOMAN'S WEDDING SHAWL (*ABOCHHINI*)
Such shawls are common throughout the region
of the Tharparkar desert and the Indus delta.

Made of white cotton, this shawl is embroidered in
red and green silk with floral motifs in radiating and
open chain stitch. Large pieces of *shisha* decorate
the central band, across which are three
pompoms with cardamom seeds.
135 × 255 cm (53 × 100 in)

VERY SIMPLE COLOURING IS USED IN THIS DESIGN WHICH IS BUILT UP USING
ONLY THREE BASIC MOTIFS. ITS IMPACT IS ACHIEVED BY MULTIPLYING THESE
MOTIFS INTO THREE DENSE AREAS OF PATTERN IN THE CENTRE.

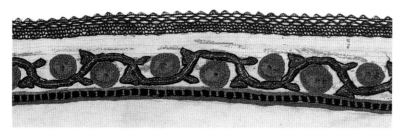

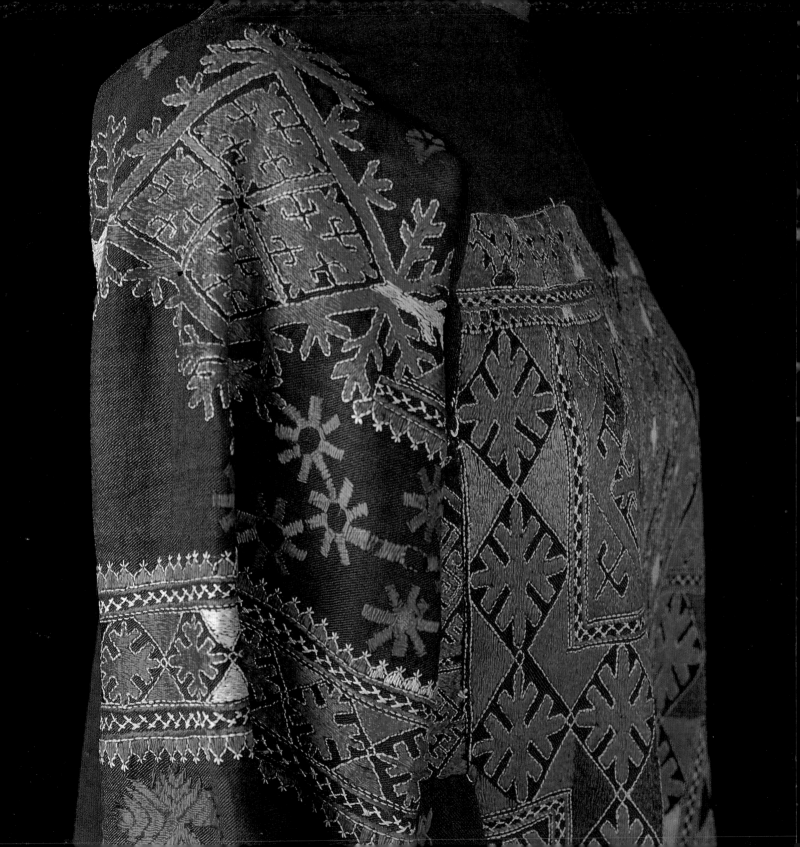

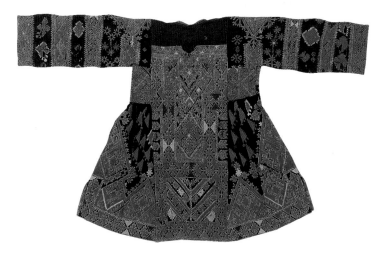

WOMAN'S SHIFT

These women's shifts, typical of the mountainous north
of the Swat valley, are distinguished by their black cotton
fabric embroidered in a zinging shocking pink.

This shift is made of patched sections, including some previously
embroidered and cut. A neck yoke of finer black fabric has been added
later. The geometric patterns are embroidered in straight stitching in
pink floss silk, outlined in yellow double running stitch. There are
touches of other shades of pink, and also purple and cream.
99 cm (39 in) × 152 cm (60 in) across arms

THIS SHIFT DESIGN FEATURES A MIXTURE OF FORMAL AND RANDOM
PATTERNING, BUT ABOVE ALL IT IS THE VIBRANT COLOUR THAT ASTOUNDS.

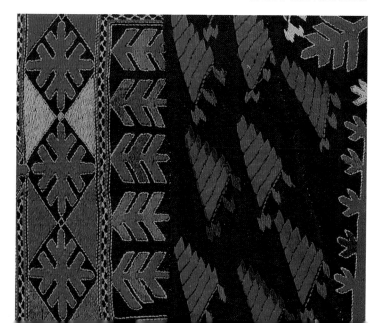

glossary

aba Muslim woman's dress worn over trousers

abla mirror glass; see also SHISHA

acrylics synthetic threads

alizarin red pigment found in madder root, also produced synthetically

appliqué technique of stitching a supplementary piece of fabric on to a background cloth

ari hook used to embroider in chain stitch; see also TAMBOUR

bagh Punjabi woman's ceremonial shawl, where almost all the fabric is covered with embroidery; see also PHULKARI

block printing decoration of a fabric by means of a carved wooden block dipped in dye

chikan floral whitework embroidery, principally from Lucknow and Bengal

chola backless bodice or blouse which forms part of the woman's costume in Gujarat, Rajasthan and Sindh.

chori Jath woman's full-skirted dress

counted thread embroidery technique whereby an even number of background threads are covered with stitchery, in contrast to freely drawn work

dhoti man's loincloth

florentine canvaswork embroidery of a wavy or flame design

floss silk raw, untwisted silk thread, obtained from the external covering of the silkworm cocoon

fulled wool woollen cloth that is felted and shrunk by the application of heat, pressure and moisture

gaghra full, gathered skirt

godet triangular piece of fabric inserted into a dress or glove to add fullness

goldwork embroidery using metallic threads

guj style of wedding dress or coat in Kutch and Sindh

gusset piece of material sewn into a garment, usually at the crotch or underarm

indigo blue dye or pigment extracted from the leaves of various plants, also produced synthetically

jap thread thread made by winding strips of paper covered in gold leaf around a silk core

jumlo traditional full-skirted dress of Indus Kohistan, worn over trousers

kameez tunic part of the *shalwar-kameez* trousers and tunic worn by both men and women in Pakistan, and also by women in India

kantha quilted embroidery of Bengal and north-east India

khaddar coarse cotton cloth, formerly hand-woven; see also PHULKARI

kohl black sulphide powder used as eye make-up

lungi length of cotton cloth worn as a loincloth

lurex synthetic metal thread

madder red dye or pigment obtained from the root of the plant *Rubia tinctorum*

malir block-printed and resist-dyed cotton, mainly red in colour, used for men's and women's shawls; also used to refer to the garment itself

mochi the work made by male professional embroiderers in Gujarat

mordant substance used to fix a dye, such as iron oxide or alum

numdah woollen rugs of the Indian subcontinent and Middle East, embroidered with simple patterns in chain stitch

pattern darning a counted-thread technique worked from the back of the fabric

phulkari 'flower-work' embroideries of floss silk on KHADDAR cotton, in geometric patterns worked from the reverse; principally from Punjab and used mainly as shawls

pudo strip of fabric stitched to the front of a dress, forming a pocket from the hem to just above the waist and finishing in an upwardly pointing triangle; a particular feature of Baluchi dress

quilting process of stitching together several layers of fabric to create a warm or protective cloth

resist dyeing technique whereby a resist substance, such as rice paste, is applied to certain areas of a design to prevent absorption of colour during the dyeing process

resist printing technique that involves the use of a resist substance together with a printing block

ricrac zigzag braiding used to decorate garments

rouleau coil or roll made of ribbon or strips of fabric

sadlo woman's shawl from Gujarat, worn over a petticoat and blouse

shalwar full, gathered trousers, part of the *shalwar-kameez* trouser and tunic costume worn in Pakistan by both men and women

shisha mirror glass, broken and cut into small pieces (usually circles) and used as a decorative feature of embroidery

soof geometric counted-thread embroidery of Sindh and Kutch

taffeta silk or synthetic fabric with with a lustrous finish

tambour type of embroidery in which the fabric is stretched over a frame and worked in chain stitch with a needle or hook; also the frame itself

tie-dyeing a dyeing process whereby patterns are produced by tightly tying areas of fabric to protect them from the dye

toran decorative frieze hung above a doorway, usually on ceremonial occasions or at shrines

turmeric yellow powder obtained from a plant of the ginger family, used for flavouring and colouring

voiding embroidery technique where areas of satin stitch are separated by a narrow strip of unworked fabric; a common feature of Chinese embroidery, also found in Swat and Indus Kohistan

whitework embroidery in white thread on white fabric

selected reading

Textiles of India and Pakistan

Askari, N. and R. Crill, *The Colours of the Indus*, London, 1997. Regional study of the costumes and textiles of Pakistan.

Crill, R., *Indian Embroidery*, London, 1999. Scholarly survey of the urban and domestic embroidery of India and Pakistan.

Elson, V., *Dowries from Kutch*, University of California, Los Angeles, 1979. Survey of the costume and dowry traditions of tribal groups in Kutch.

Ghuznavi, S.R., *Naksha*, Dhaka, 1981. Illustrations of designs used in Bangladeshi crafts, particularly textiles.

Gillow, J. and N. Barnard, *Traditional Indian Textiles*, London, 1991. Detailed study of the textiles of each region of India.

Irwin, J. and M. Hall, *Indian Painted and Printed Fabrics*, Ahmedabad, 1971. One of the first surveys of Indian textiles, describing the collections of the Calico Museum in Ahmedabad.

Indian Embroideries, Ahmedabad, 1973. Companion volume to the above, covering the Calico Museum's collections of embroidery.

Moharty, B.C., *Appliqué Craft of Orissa*, Ahmedabad, 1980. Appliqué pieces in the collections of the Calico Museum and an introduction to their geographical and historical background.

Morrell, A, *The Techniques of Indian Embroidery*, London, 1994. Working details of all the techniques and stitches used in Indian embroidery.

Nana, S., *Sindhi Embroideries and Blocks*, Karachi, Govt. of Sindh, 1990. Analysis of Sindhi design motifs, including descriptions of the stitches and printing blocks.

Paine, S., *Chikan Embroidery*, Shire, Aylesbury, 1989. Analysis of the floral whitework of Lucknow and Bengal.

Sarabhai, M.V., *A Stitch in Gujarat Embroidery*, Ahmedabad, 1977. Black-and-white illustrations of Gujarati motifs.

Whitechapel Art Gallery, *Woven Air*, London, 1988. Series of papers on the *jamdani* weaving and *kantha* traditions of Bengal and Bangladesh.

Zaman, N., *The Art of Kantha Embroidery*, Dhaka, 1981/93. Description of the techniques, motifs and regional diversity of the *kantha* quilt tradition of Bengal and Bangladesh.

Village arts and crafts

Huyler, S.P., *Painted Prayers*, London and New York, 1994. Photographic survey of the ritual paintings of village women in India.

Iwatate, H., *Desert Village, Life and Crafts*, Tokyo, 1989. Illustrations of the crafts of the people of Gujarat and Rajasthan, featuring textiles in particular.

Kalter, J. (ed.), *The Arts and Crafts of the Swat Valley*, London and New York, 1991. Papers on all aspects of arts and crafts in the Swat valley of northern Pakistan.

Nicholson, J., *Traditional Indian Arts of Gujarat*, Leicester, 1988. The daily life, crafts and textile techniques of the people of Gujarat.

Court life and textiles

Archer, M., C. Rowell and R. Skelton, *Treasures from India*, The National Trust, 1987. The arts and crafts, including textiles, in the Clive collection at Powis Castle.

Askari, N., *Treasures of the Talpurs*, Karachi, 1999. Collections of arts and crafts, including textiles, from the courts of Sindh.

Kumar, R., *Costumes and Textiles of Rural India*, London, 1999. The sumptuous textiles of the Indian courts, with some rural work and descriptions of techniques.

Patnaik, N., *A Second Paradise*, New York, London and Calcutta, 1985. Courtly life in India between 1590 and 1947.

Victoria and Albert Museum, *The Indian Heritage*, London, 1982. Catalogue of an exhibition on court life and arts in India under Mughal rule.

Nomadic peoples

Fisher, N. (ed.), *Mud, Mirror and Thread*, Ahmedabad, 1993. Study of the role of textiles and other crafts in the lives and beliefs of the people of rural India, in particular the Banjara and Rabari.

Frater, J., *Threads of Identity*, Ahmedabad, 1995. Survey of the lives of the Rabari, their costume and embroidery.

Randhawa, T.S., *The Last Wanderers*, Middletown, N.J. and Ahmedabad, 1996. The lives and crafts of the last itinerant people of India.

The Sikhs

Stronge, S. (ed.), *The Arts of the Sikh Kingdoms*, London, 1999. Study of the cultural heritage of the Sikhs, including a section on the textiles of Punjab.

General

Paine, S., *Embroidered Textiles*, London, New York and Bern, 1990/1995/1997. Study of the source of many patterns in religions, cults and beliefs.

museum accession numbers

PAGE	ACC. NO.
2	1991 As 18.25
4	1966 As 1.596
7	1966 As 1.475 (top)
7	1987 As 11.42 (left)
7	1987 As 11.36 (right)
7	1987 As 11.13 (below)
22	1991 As 18.25
25	1985 As 19.103
26	1993 As 21.1
28	1966As 1.475
33	1991 As 18.70
34	1993 As 21.2
36	1970 As 4.1
38	1987 As 11.13
41	1987 As 11.54
45	1986 As 9.29
46	1986 As 11.2
49	1986 As 9.14
51	1966 As 1.476
52	1986 As 9.18
55	1966 As 1.506
56	1952 Af 20.51
58	1987 As 11.36
63	1984 As 8.6
64	1985 As 14.6
66	1984 As 8.55
69	1987 As 11.42
70	1984 As 8.60
72	1984 As 8.8
75	1986 As 9.48
76	1966 As 1.596
79	1984 As 8.42
81	1986 As 9.43
INSIDE COVER	1987 As 11.13

publisher's acknowledgements

The textiles featured in this book are drawn from the collections of the British Museum's Department of Ethnography and have been selected from the viewpoint of their design and technical merit.

We should like to express our thanks to the many people who have helped us in the production of this book, and in particular from the Museum staff: Helen Wolfe, Imogen Laing and Mike Row. Paul Welti, the art director, must be credited not only for his arresting juxtaposition of illustrations and text, but also for his contribution to the captions analyzing the designs.

picture credits

author's acknowedgements

The author would like to thank John Gillow for sharing his knowledge and love of India.

index

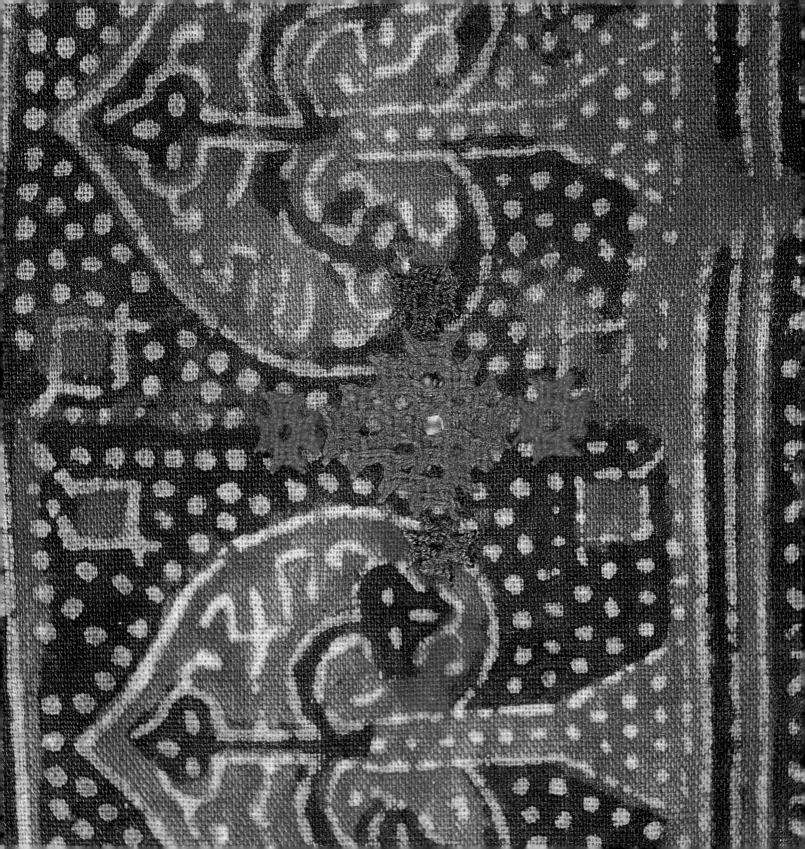